XMAS 1998
Harry — I saw this Book
and thought of you — I
know it will bring back
memories — Hope you enjoy
it. Sorry Brown

Harry XMAS Happy New Year

Golf
in
Hollywood

Golf in Hollywood

Where the Stars Come Out to Play

By Robert Z. Chew and David D. Pavoni

Designed by Dello & Associates

ANGEL CITY PRESS

ANGEL CITY PRESS, INC.
2118 Wilshire Boulevard, Suite 880
Santa Monica,California 90403
310.395.9982
http://www.angelcitypress.com

Golf in Hollywood by Robert Z. Chew and David D. Pavoni
First published in 1998 by Angel City Press
10 9 8 7 6 5 4 3 2 1
FIRST EDITION
ISBN 1-883318-08-4
Copyright © 1998 by Robert Z. Chew and David D. Pavoni
Designed by Dello & Associates, Inc. — Art Director: Joseph Jacobs

Distributed to the book trade by Universe Publishing through St. Martin's Press, 175 Fifth Avenue, New York NY 10010

Printed in Hong Kong

LIBRARY OF CONGRESS CATALOGING-IN-PUBLICATION DATA

Chew, Robert Z., 1953-
 Golf in Hollywood : where the stars come out to play / by Robert Z. Chew and David D. Pavoni.—1st ed.
 144 p. cm.
 Includes bibliographical references and index.
 ISBN 1-883318-08-4
 1. Golf — California — Los Angeles — History. 2. Golf — California — Hollywood (Los Angeles) — History.
 3. Motion picture actors and actresses — Recreation. I. Title.
 GV983.L7C54 1998
 796.352/09794/93 21
 98025484 CIP MN

For my father, who has taught me everything about golf and life.

— R.Z.C.

To my wife Renee, for her support and understanding.

— D.D.P.

Foreword

When we began this project, we wanted to create a book on golf and its relationship to Hollywood. The idea was to capture the celebrity history of the game and to chronicle for the first time, and in one place, not just the players, but the legendary golf courses, their designers and the numerous stories shared by so many in Hollywood.

Once we delved into the research, photo libraries and the clubs themselves, we realized the depth and scope of Hollywood's long-lasting love affair with the game. In fact, we discovered that one of the first "moving picture" short films made in the 1890s featured elements of golf.

It was only natural that the sunny climes of Hollywood and the casual ambience of the golf course would become a perfect setting for deal making. Early movie moguls such as Louis B. Mayer and Hal Roach spent hours playing golf with stars, treating the fairways like a private meeting room. The industry's first golf couple was the silver-screen powerhouse team of Mary Pickford and Douglas Fairbanks. Leading men Clark Gable, Gary Cooper and Randolph Scott were never far from the links. As for the women, Katharine Hepburn was a better golfer than many of her male leads. And Dinah Shore held her own tournament.

Today, the golf tradition continues in Hollywood. From Jack Nicholson to Kevin Costner to George Clooney, the game still intrigues and mystifies the rich and famous just as it has for nearly a century. Courses at Riviera, Lakeside, Bel-Air and Hillcrest country clubs were, and still are, second homes to many of the world's most famous names and faces.

The "Golden Era" of golf in Hollywood has faded, but in this book we hope to restore some of its luster and to examine the game that still beckons to new generations of Hollywood stars.

Robert Z. Chew and David D. Pavoni
Los Angeles, 1998

Contents

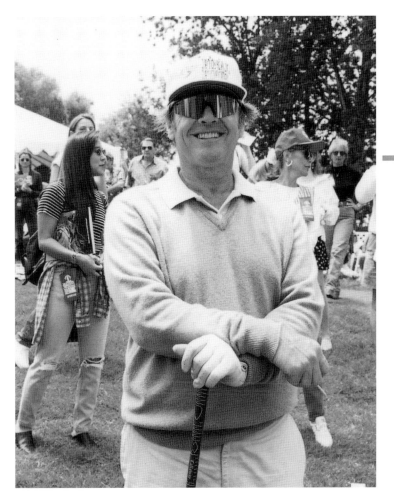

Golf and the movies grew up together in Hollywood. And the pairing was a hit from the earliest days of filmland's Golden Era. Both the game and film stars have always attracted crowds of fans. Today the public still goes wild when they attend a charity tournament and see celebrities such as Jack Nicholson getting ready to play.

Part III

The Modern Era

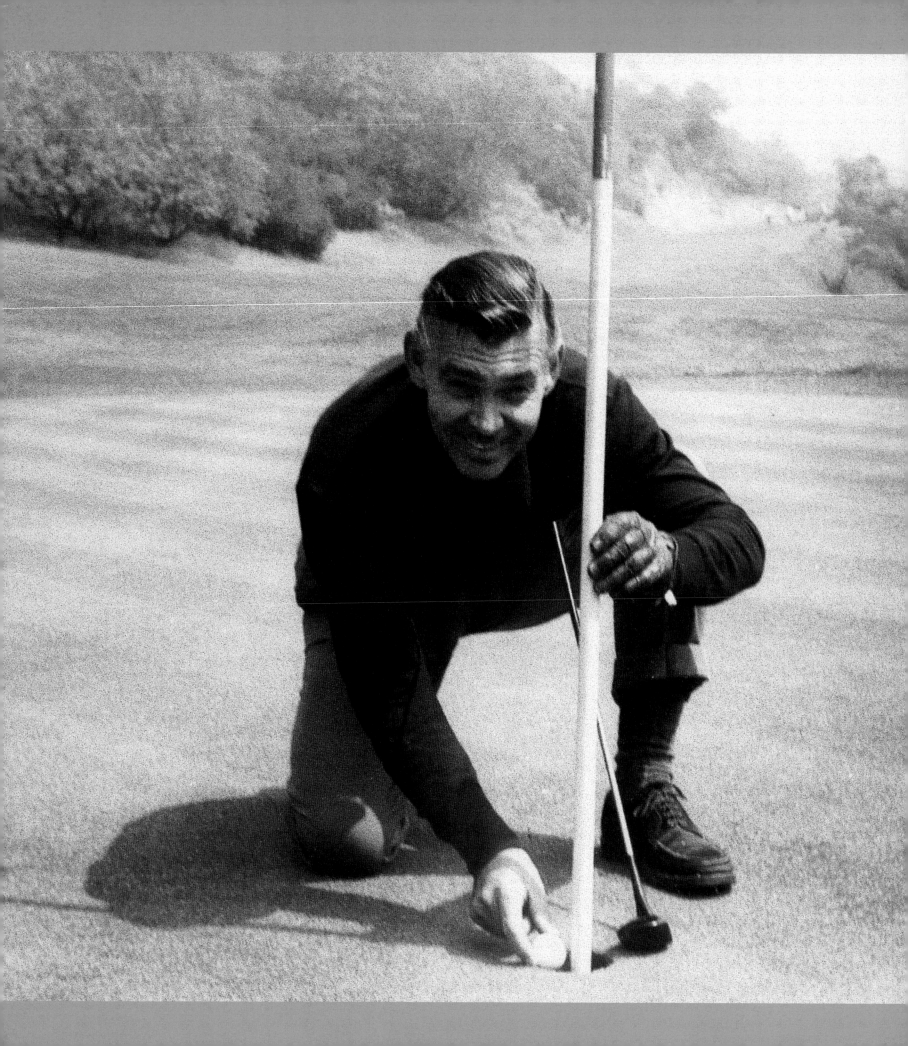

Part I

Hollywood's Enduring Passion

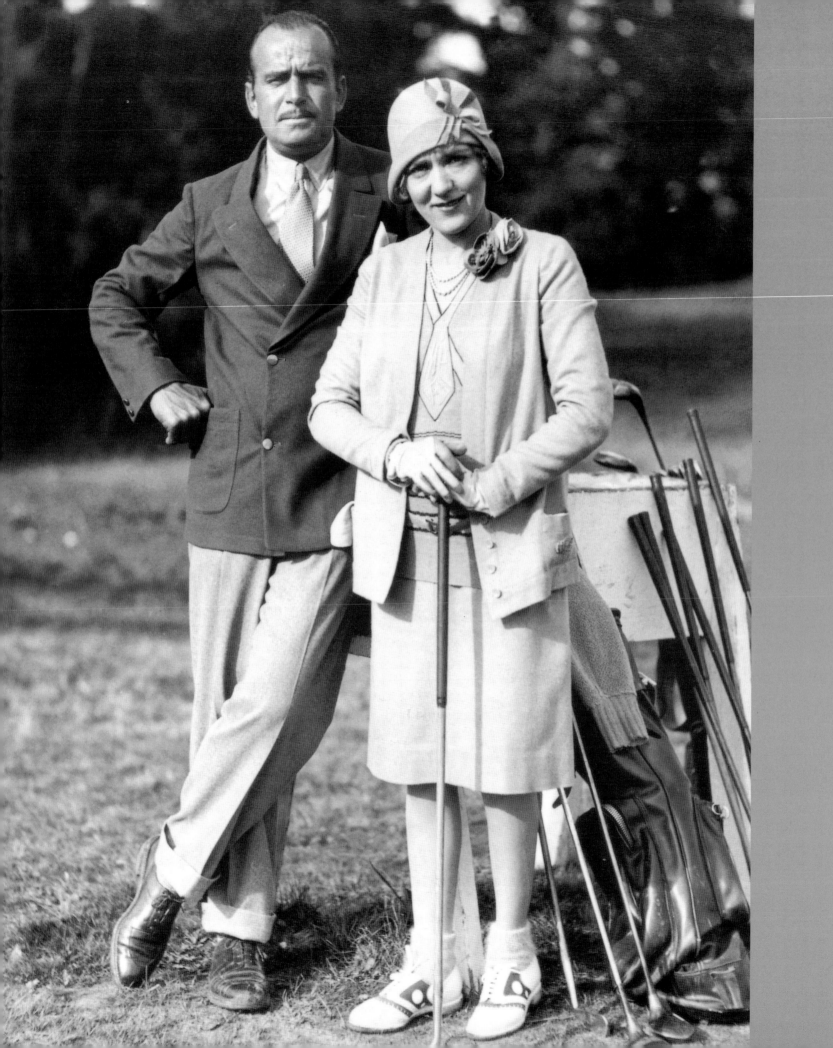

Chapter One
The Golden Era

In a tradition that goes back to the silent age of Hollywood in the early 1900s, when the motion picture industry left New York for the warm, predictable climate of southern California, the game of golf has always been a favorite pastime for celebrities. The art of golf in Hollywood is mixing business with pleasure. There has always been a symbiotic relationship between the game, the business of movie making, and those who yearned for their names in lights. Playing golf in Hollywood often was, and still is, where the idea forms, the deal starts and the next star is born.

Today the screen's biggest stars play the game or are attempting to learn it. Jack Nicholson is frequently on the fairways at Bel-Air, flashing that patented sly grin after draining a long putt. For his role in the movie *Tin Cup*, Kevin Costner took up golf, became a regular at Riviera Country Club and is a ubiquitous figure on the celebrity tournament circuit. His instructor for the movie, touring professional Gary McCord, said Costner was such a fast learner that no expert-golfer double was used. Costner admits he is "hooked" on the game and counts the golf phenomenon Tiger Woods among his closest friends. Stars who are relatively new to the screen, such as Will Smith of *Men in Black* fame, are committing their energy, time and money to the game. Smith, for instance, is a faithful at the Studio City Driving Range where he takes lessons, and then follows up with practice sessions on his

own backyard green. But the truth is that although many actors are big at the box office, very few are great on the golf links. New-to-the-game celebrity golfers are quickly humbled on the fairways of Hollywood. Most have double-digit handicaps and even with practice will remain in the "Above-90" club.

That wasn't always the case. In the "Golden Era" of the film industry, names such as Pickford and Fairbanks, Crosby and Hope were common on scorecards. Stars were teeing off at several great courses, but the most renowned celebrity courses were, and continue to be, Lakeside Golf Club, Bel-Air Country Club and Riviera Country Club. The legendary couple Douglas Fairbanks and Mary Pickford were ardent golfers and began their playing days at Lakeside in 1926. Eventually, they moved over to Riviera in 1927. After joining Riviera, Fairbanks and Pickford brought their Hollywood friends with them, including Mack Sennett, Harold Lloyd and Hal Roach.

In Lakeside's early years, W.C. Fields and Oliver Hardy were members and frequent companions on the links. They played extremely long rounds with regular belts off Fields' hip flask and frequent trips into the woods to retrieve lost balls. It was said that they played their golf sideways.

During the 1930s, Hollywood studios would send vans to Bel-Air Country Club to retrieve actors who neglected cast and crew calls for a round of golf. Randolph Scott said that Gary Cooper was never caught because he was skinny enough to hide behind trees and avoid being seen. Ray Bolger, the dancer/actor most famous

In 1927, Hollywood's power couple, Douglas Fairbanks and Mary Pickford, pose at the newly opened Riviera Country Club. After their divorce, Pickford continued to play golf with her third husband, entertainer Charles "Buddy" Rogers.

Photo on page 10: Clark Gable was one of the many Hollywood stars who frequented the exclusive country clubs and golf courses during the Golden Era of filmmaking. Here, he celebrates a hole-in-one.

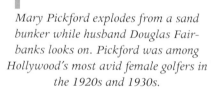

Mary Pickford explodes from a sand bunker while husband Douglas Fairbanks looks on. Pickford was among Hollywood's most avid female golfers in the 1920s and 1930s.

Dapper actor Richard Arlen was one of Hollywood's leading men and golfers in the 1920s and 1930s. He starred in Wings, *the first movie to win the Academy Award for Best Picture. Arlen played most of his golf at Lakeside Golf Club, often teaming up with W.C. Fields and Oliver Hardy.*

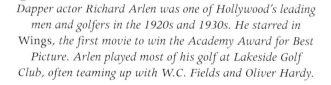

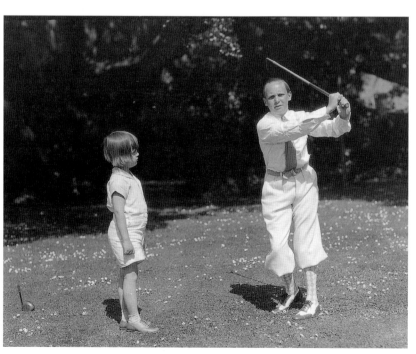

Child actor Jackie Coogan (swinging club) tees it up with his younger brother at Rancho Golf Club. While filming at MGM, Coogan was frequently chauffeured to nearby Rancho for a few quick holes between takes.

for his role as the Scarecrow in *The Wizard of Oz*, was a golfing fanatic. The studio didn't have to send a van for him because at first light he would get to Bel-Air, and sprint to his next shot. He finished his nine holes before each day's filming began.

Some of the best celebrity golfers were crooner Bing Crosby, a onetime 2-handicapper and Lakeside Golf Club champion, western bad guy Bob Wilkie and 1950s television star Bob Sterling. The MGM star Dennis O'Keefe once qualified for the Los Angeles Open and frequently challenged Wilkie, Sterling and Crosby at celebrity tournaments. Johnny Weissmuller, known for swinging in trees as Tarzan, was also known for his swing on the course. He and fellow actor Forrest Tucker were among Hollywood's longest hitters and often scored in the 70s.

Perhaps the most enduring legacy associated with golf in Hollywood is the plethora of rich stories, myths and anecdotes that have been handed down by the players and the clubs where they played. Hollywood's best golf stories have often been passed from caddies to starters to club members to the press. Although over the years some of these stories have been embellished and altered, they are still retold to countless newcomers on southern California golf links. Like their images on celluloid, the golfing legends of Hollywood's brightest stars are still alive on the greens.

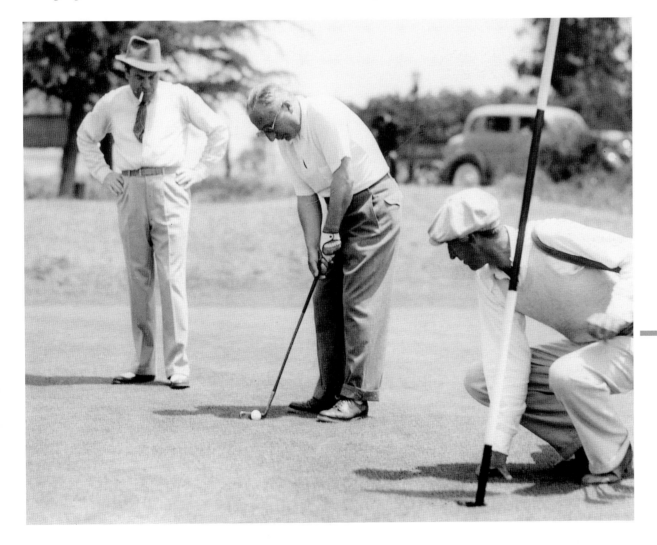

In 1939 MGM executive Eddie Mannix, left, and president Louis B. Mayer, center, celebrate the success of Gone With The Wind *with a round of golf.*

Silent film legend Harold Lloyd practiced on his backyard course designed by famed golf-course architect Dr. Alister MacKenzie. Lloyd was a member at Riviera Country Club and one of the few celebrities allowed to join Wilshire Country Club.

Douglas Fairbanks putted with a casual stroke. Fairbanks was so involved at Riviera Country Club that he donated one thousand dollars to help draw golf's best players to the 1929 Los Angeles Open held there.

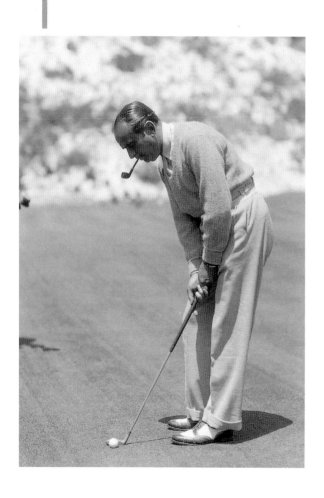

Douglas Fairbanks, Jr., left, with his father at Lakeside Golf Club. After his divorce from Mary Pickford, Fairbanks, Sr., played most of his golf with his son at Lakeside.

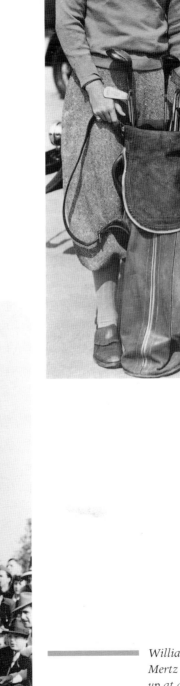

William Frawley, the famed Fred Mertz of TV's I Love Lucy, *tees it up at a celebrity war bond tournament. His gentle demeanor made him one of Lakeside Golf Club's most beloved members.*

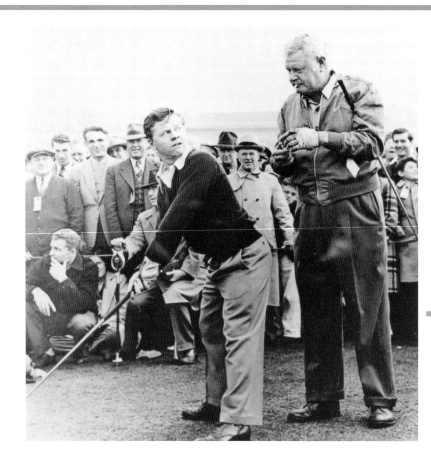

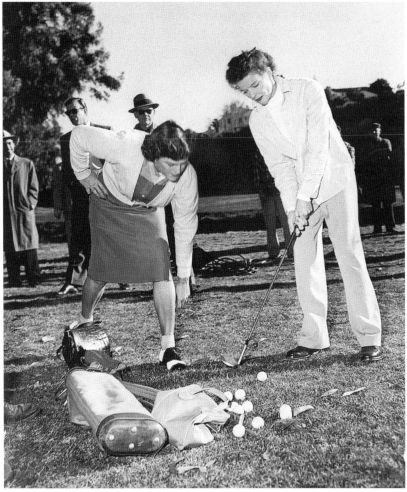

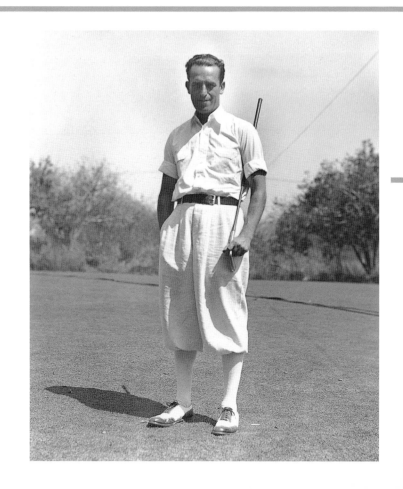

Spencer Tracy gets some pointers from female golf professional Bettye Jamieson at Bel-Air Country Club. Tracy was practicing for his role in the 1952 MGM film Pat and Mike, which co-starred his longtime love Katharine Hepburn.

Humphrey Bogart, one of Hollywood's better players, pauses on the practice tee at Lakeside Golf Club. When filming at nearby Warner Brothers studio, Bogart often snuck over to the club for a quick round.

Alan Hale clowns with fellow actor Mickey Rooney. Rooney, a one-time single-digit handicapper, was known for his mercurial temperament on the golf course. Lakeside members said that Rooney's putter saw more air time than Charles Lindbergh.

Professional golfer Babe Didrickson, left, helps Katharine Hepburn with her short game.

Harold Lloyd poses at Wilshire Country Club during the 1920s.

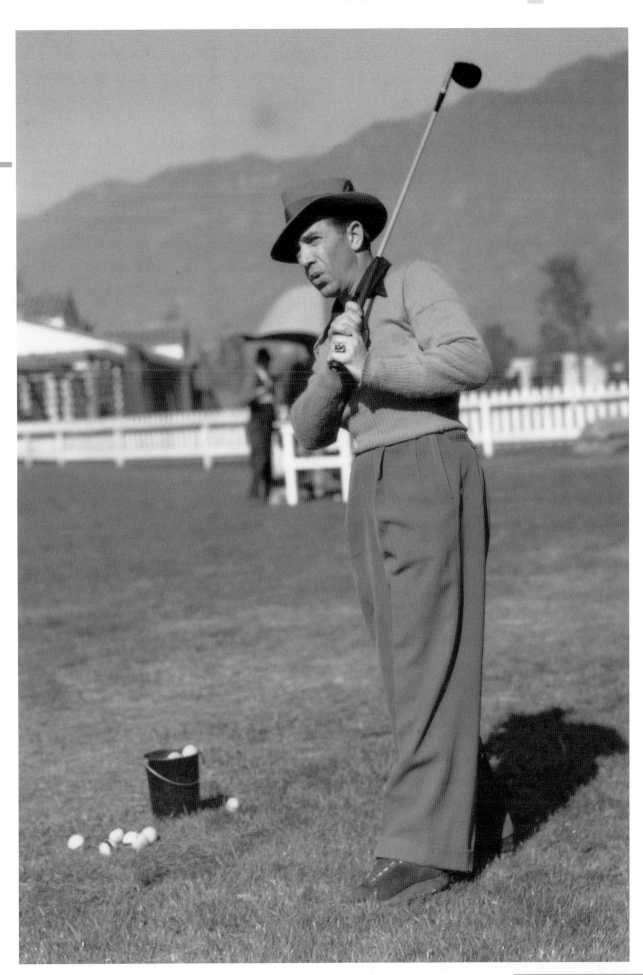

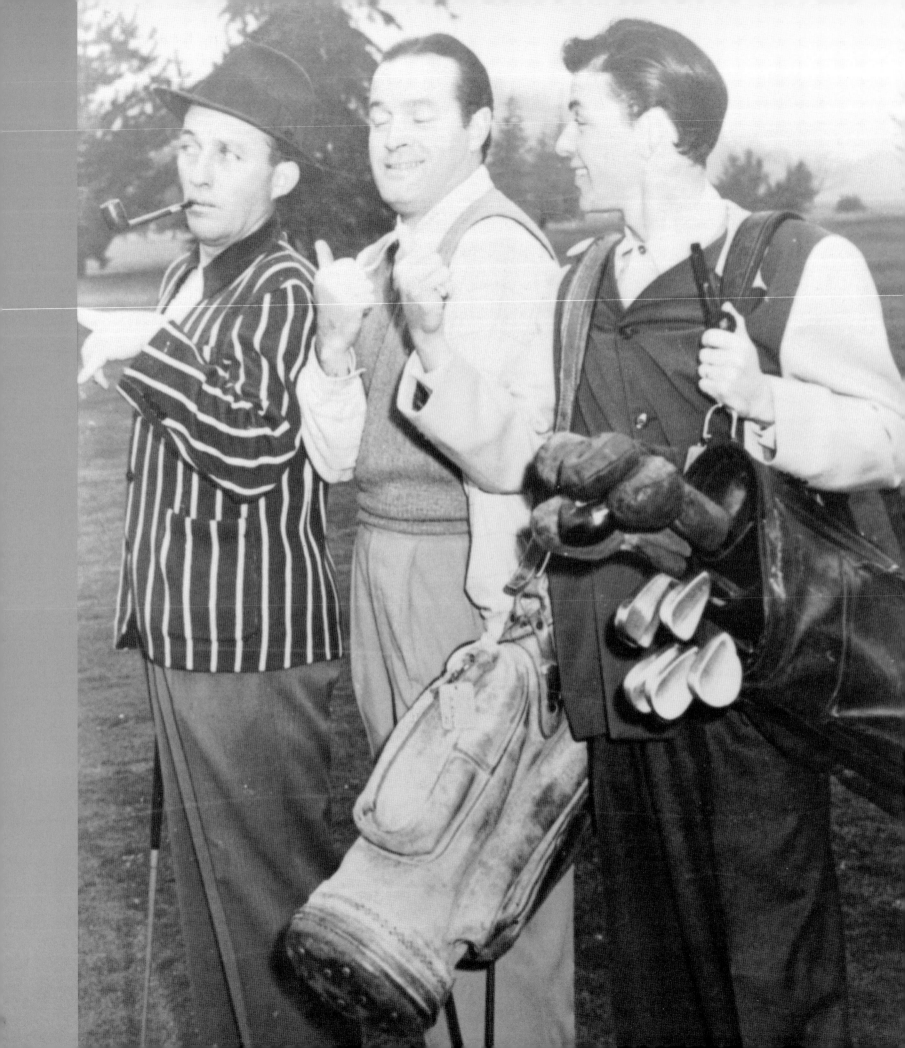

Bing Crosby
Hollywood's Golf Icon

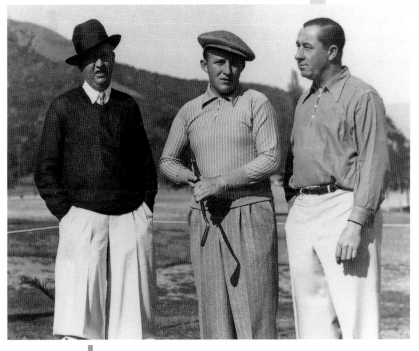

Young crooner Bing Crosby, center, joins Macdonald Smith, left, and Walter Hagen at Lakeside Golf Club. Crosby honed his game by playing up to seventy-two holes a day and learning from touring professionals.

In his autobiography *Call Me Lucky*, Bing Crosby wrote that golf and Hollywood, when mixed astutely, created the foundation for a legendary career. He was speaking from personal experience. Crosby first came to Los Angeles in 1926 with song-and-dance partner Al Rinker. They were performing two shows a day at the Metropolitan Theater and loved to sneak away to play golf. This was before Crosby was famous, so they often hopped in their roadster and drove over to the public golf courses at Griffith Park. Crosby, however, had a special knack for working his way into better surroundings. Crosby ran into a local golf pro, Jock McLean, at Griffith Park and it turned out McLean was a fan of his music.

Crosby and Rinker gave McLean special treatment, inviting him backstage for post-performance parties. In return, they hoped McLean would be able to get them onto one of Hollywood's better private courses. Happy to oblige, McLean let them play at Wilshire with the stipulation that the guys were off the first tee by 6:30 am and finished by 8:30 am, before members began their rounds. McLean offered one other caution. He told them to stay away from a certain gentleman, a genuine tightwad and miserable old codger who despised non-members playing at his club.

A slender Frank Sinatra plays caddy for Bing Crosby and Bob Hope during a war bond drive tournament at Lakeside Golf Club. A raffle prize was awarded to whomever bought the most bonds. The prize was a kiss from Sinatra.

One morning, the pair was a little late getting off the course. Their 8:30 "checkout" time came and they only had reached the 10th green. As Crosby was about to putt, he noticed someone on the 10th tee ready to play. Not expecting to have players on the green, the man hit his tee shot and the ball bounced near Crosby and Rinker. Upset by such rudeness, Crosby gave the ball a light boot. It jumped a trap and skipped into the hole.

When the old gent approached the green looking for his ball, Crosby told him to look in the hole. There it was — a hole-in-one. Ecstatic, he dragged the pair into the clubhouse to verify his first "hole in one." He called friends, opened champagne and led celebrations late into the afternoon, all the while with Crosby and Rinker at his side. Too drunk to perform, the two unknown entertainers canceled their afternoon show and barely sobered up in time for their evening performance, with their newfound friend and his club cronies in the audience. Later that evening, there was more drinking, dining and dancing at the Coconut Grove.

The next morning, Crosby and Rinker were feeling hung over and guilty about letting the member carry on about his bogus "ace." The guilt vanished quickly, however, when McLean showed up with a pair of complimentary two-month memberships. Ironically, the man who authorized the two free passes was the old tightwad McLean had warned Crosby and Rinker about earlier. So, with a boot of a ball, Crosby started his golf career in Hollywood.

Crosby was a master at "power schmoozing" on the golf course, securing both music and movie deals. With a singing career in full swing, it was not long before his film career took off, too. In 1930, he joined the golf club nearest Warner Brothers studios: Lakeside. There, Crosby happened upon producer Mack Sennett and the resident golf pro, Willie Low. Crosby asked if he could join them. When Sennett wanted to know who Crosby was, Low informed him: "Mack, it's Bing Crosby, the singer. He's all the rage at the Coconut Grove and the women are wild about him." Sennett was happy to play with the young singing sensation. After the match finished, Crosby, Sennett and Low were having a drink in the Men's Bar. The producer asked Crosby if he wanted to visit his studio. Never one to miss an opportunity, Crosby asked when it might be convenient. Within a few weeks, Crosby was reprising his musical hits in Sennett one-reel shorts. It was the start of Crosby's long and illustrious film career, culminating in the successful "Road" pictures with Bob Hope.

Crosby's game improved during the 1930s and 1940s. His handicap dropped to 2, a level low enough to compete with top players of the day. He played and practiced with great golfers

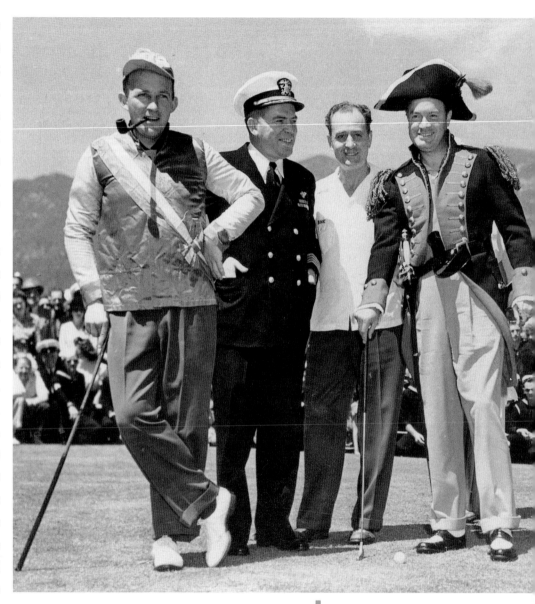

Crosby, Hope, sportswriter Scotty Chisolm (in kilt) and unidentified golf enthusiasts at a World War II Victory Tournament in Ojai, California. Similar events raised millions of dollars for the war effort (note sailors in background).

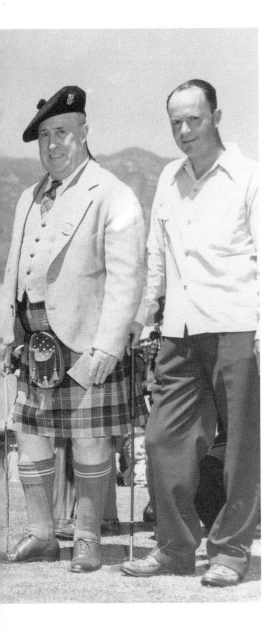

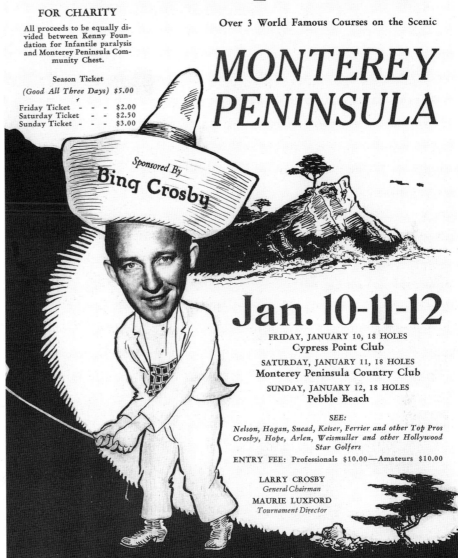

A 1947 poster for the Crosby Pro-Am in its first year on the Monterey Peninsula. It moved from Rancho Santa Fe to Pebble Beach after the war. Its ten-thousand-dollar purse made it a big draw for professionals, amateurs and celebrities alike.

regularly, often between scene set-ups and prior to the day's filming. He arrived early at Lakeside and, if there were no members around, played with the caddies, many of whom were accomplished golfers. When asked how he became such a good golfer, Crosby said "by playing up to seventy-two holes a day on many occasions with caddies, and watching pros play with pros." Crosby was club champion at Lakeside four times. he was a member at Bel-Air, but was asked to leave one day when he refused to stop hitting practice balls off the 10th tee. He obliged, but never returned to the club.

Bing was famous for being frugal, even when it came to his favorite sport. At a big-money golf match in Las Vegas, Crosby once put five hundred dollars on a team and Los Angeles real-estate developer Carl Anderson bet five hundred dollars on another. Anderson's team won and Bing paid him the money. The win was regaled in locker rooms around the area and with each telling the amount grew. It was not long before the I.R.S. knocked on Anderson's office door asking for its cut of the winnings. They had heard about the fifty thousand dollars he had won on Bing Crosby's bet. A stunned Anderson responded: "Fifty thousand dollars? It was only five hundred. Crosby wouldn't pay a dime to see a re-enactment of the Crucifixion with the original cast."

Bing Crosby's golf legacy, much like Bob Hope's, was introducing the benefit golf tournament to the entertainment community. The popular crooner initiated the "Crosby Clambake" in Rancho Santa Fe near San Diego in 1937. At the time, professional golf tournaments paid relatively low purses, rarely exceeding five thousand dollars. Crosby's first Rancho Santa Fe Pro-Amateur Golf Tournament had a purse of three thousand dollars, big enough to attract many of the game's top professionals as well as players from the entertainment world. Among the many celebrities to play in the Crosby in the early years were actors Hope, Johnny Weissmuller, Andy Clyde, Guy Kibbee, George Murphy and Richard Arlen.

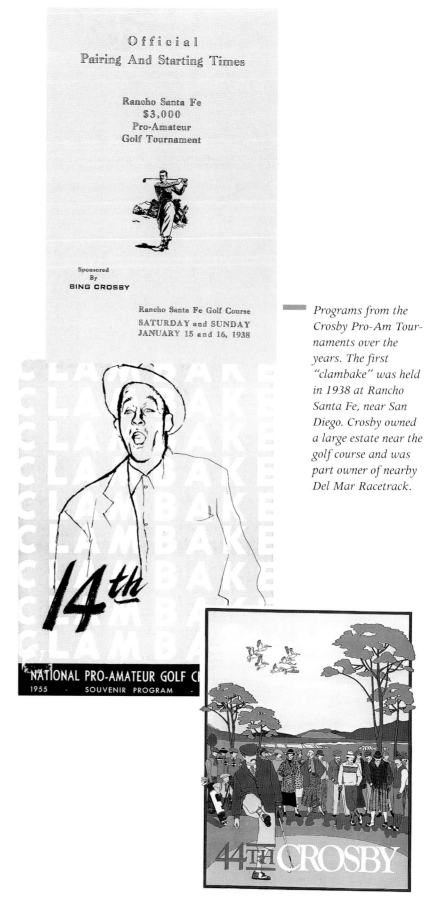

Programs from the Crosby Pro-Am Tournaments over the years. The first "clambake" was held in 1938 at Rancho Santa Fe, near San Diego. Crosby owned a large estate near the golf course and was part owner of nearby Del Mar Racetrack.

A big part of the tournament's fun was the "clambake," where Crosby and friends would entertain into the small hours with songs, jokes and skits. Many of the participants would be horribly hung over for their morning rounds, but participating in the late-night activities was mandatory if a player wanted to be invited back. Stuffed-shirts were not welcome at the "Crosby."

The Crosby was held at Rancho Santa Fe until 1942, when it was put on hold for the war. During those years, Crosby participated in numerous Victory Tours and war bond tournaments, along with Hope and other Hollywood luminaries. In 1947, the Crosby started up again at a new location, the world-famous golf links at Pebble Beach on the Monterey Peninsula. The event was spread over three great golf courses: Pebble Beach, Cypress Point and Monterey Peninsula Country Club. In later years, both the Monterey and Cypress courses were replaced with Spyglass Hill and Poppy Hills links. The Crosby became the most popular pro-am in the world and was first televised nationally in 1959. Old traditions such as the late night clambake revelry continued at The Lodge at Pebble Beach while new ones were introduced, such as Crosby singing "Straight Down The Middle," a song written by Sammy Cahn and Jimmy Van Heusen for his tournament.

After Crosby's death in 1977, his wife Kathryn, pressured to change its name to the AT&T Bing Crosby Golf Tournament, declined and pulled his name from the event. Today, the tournament is the AT&T Pebble Beach National Pro-Am. Although it is held in January, an often tumultuous time for weather on the Monterey Peninsula, top PGA players and Hollywood celebrities still flock to the event. Over the years, the tournament Crosby created has raised millions of dollars for various youth organizations in and around Monterey.

Crosby played golf, literally, until the day he died. In October of 1977, he was playing golf on the La Moraleja course near Madrid. He shot an 85. After sinking his final putt on 18, Bing turned to his companions and said, "It was a great game." As he left the green for the clubhouse, he collapsed and died. With Crosby's death, golf's Golden Era in Hollywood ended.

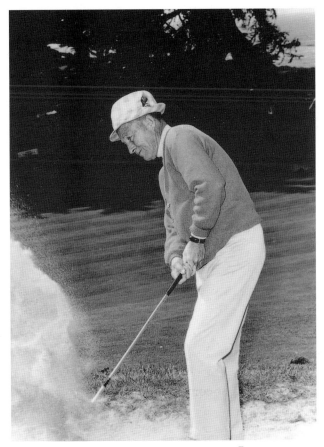

Even in his later years, Crosby scored in the 70s and 80s, using a delicate touch out of sand bunkers like this one.

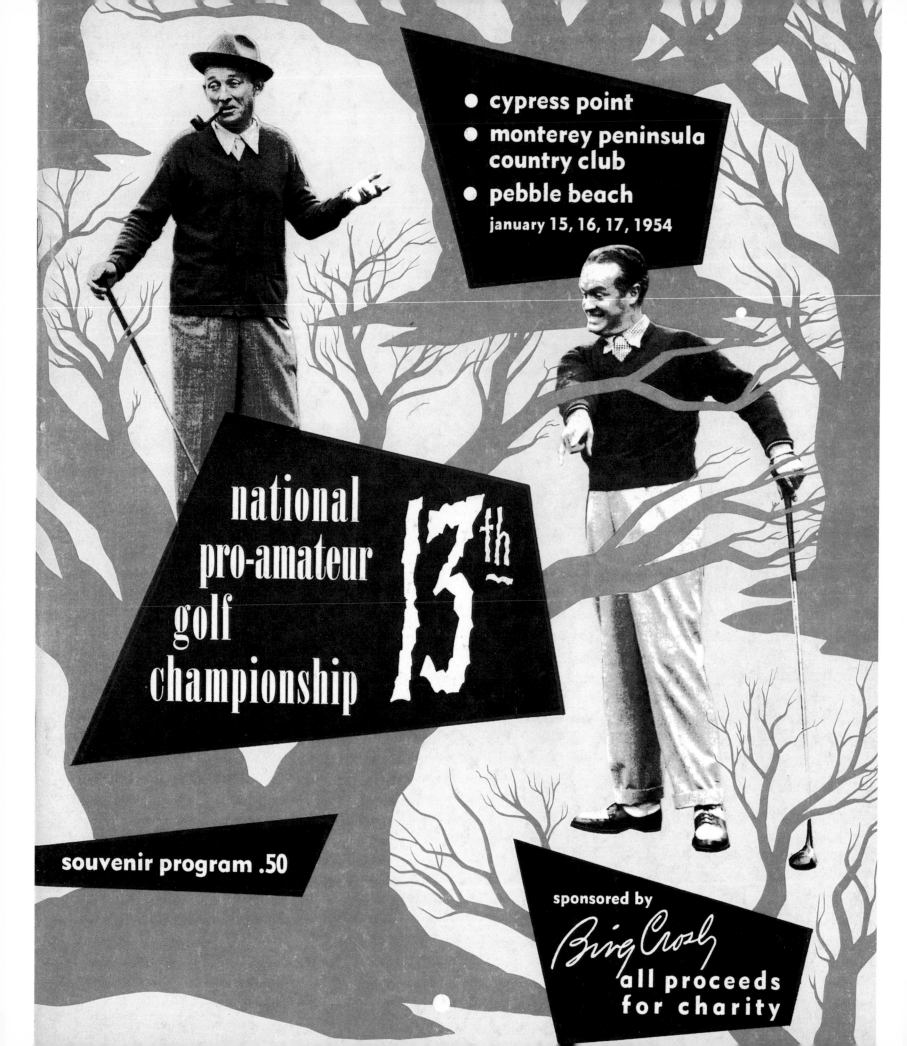

SOUVENIR

6th annual

Celebrity GOLF TOURNAMENT

SUNDAY, JUNE 5, 1966
MARCH AFB, CALIFORNIA

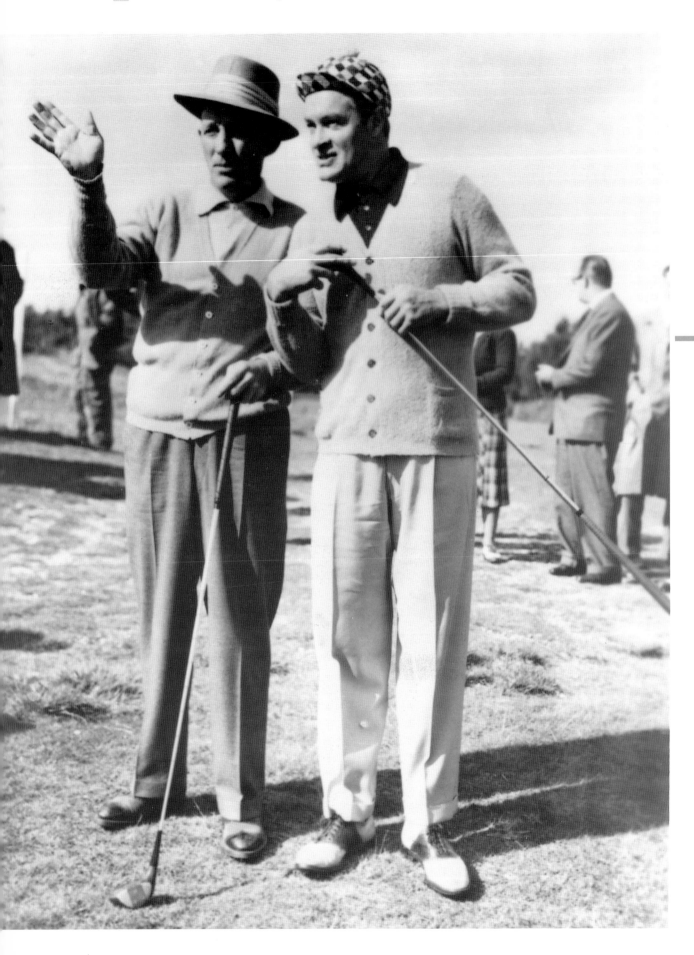

Hope and Crosby first met in New York in the late 1920s and rekindled their friendship when Hope moved to Los Angeles in 1937. Although their golf rivalry was legendary, Crosby, in fact, won most of their matches. In 1953, Golf Digest featured the two on its cover with a headline: "Why Crosby Beats Hope."

Preceding pages: These original program covers from the Bing Crosby Pro-Am and from the Celebrity Golf Tournament at March Air Force Base, hosted by Bob Hope, show the importance of the stars' images at west coast tournaments.

Bob Hope
Thanks for the Golf Memories

As a young vaudevillian, Bob Hope first played golf in the mid-1920s on the golf courses around New York. But it wasn't until he signed a movie deal with Paramount Pictures in 1937 and moved to Hollywood that the game got into his blood.

In 1938, Hope, like a lot of Hollywood's entertainers, joined Lakeside Golf Club because it was close to the studios, and his good friend Bing Crosby was a member. Hope made things even more convenient for himself and wife Dolores by moving into a home situated directly on Toluca Lake, a small kidney-shaped body of water behind the club. Hope's love for the game inspired him to install his own par-three course on his property.

During World War II, Hope not only entertained troops, he played in numerous Victory Tours and war bond drives that featured golfers from the A-List of Hollywood, including Crosby, Gary Cooper, Fred MacMurray, Johnny Weissmuller and Harpo Marx.

Like Crosby, the stories about Hope and golf are legendary. Once, just after World War II, Hope was in England and met up with Humphrey Bogart. The friends spent one evening drinking in the private casinos of London and then returned to their hotel. Both played at Lakeside, so they reminisced about Hollywood and the crazy things that happened at the club. Bogart eventually talked Hope into lying on the floor, putting gum on his nose (to set the ball) letting him stand above him with a golf club. Bogart lined up the club to the ball and hit it off Hope's famous ski-slope nose, the ball ricocheting around the room. Hope claims he has not been able to breathe properly since.

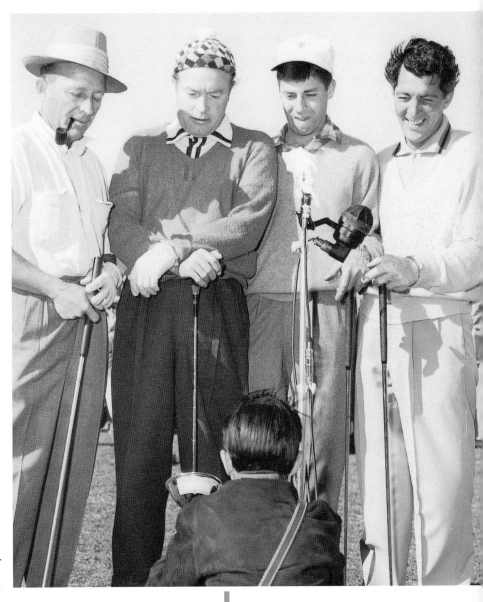

Crosby, Hope and the young comedy team of Martin and Lewis ham it up during a promotional photo session for the 1953 Paramount movie The Caddy.

Hope and Crosby played golf together frequently, and bets were fast and furious on the first tee. On one occasion Hope lost the match and had to work one day free of charge on Bing's movie *Doctor Rhythm*. Hope's golf game improved over the years. At one point, his handicap dropped as low as a 4. Crosby, however, was a better player and rarely lost to his movie partner. In 1951, Hope qualified for the British Amateur, a huge feat for a full-time entertainer.

In 1962, Hope's pal Jackie Gleason moved his variety show from New York City to Miami so he could play golf every day. When in Florida, Hope frequently made the rounds with "The Great One." They played for high stakes, usually one hundred dollars a hole and double or nothing on the 18th. In his 1985 book, *Confessions of a Hooker: My Lifelong Love Affair with Golf*, Hope said he and Gleason paid each other after each hole because they tended to get scores and finances confused. Hope called Gleason the only guy he knew who had a bartender in his golf cart.

Hope's renowned gift to the golfing world is the Bob Hope Desert Classic, which began in 1959 and has taken place every January in Palm Springs since its inception. It features a 90-hole format that demands four courses: Indian Wells, La Quinta and Bermuda Dunes, as well as Tamarisk or Eldorado, which alternate

Longtime friend and fellow actor Phil Harris watches as Hope and Bing Crosby contemplate a putt at an early 1960s celebrity tournament.

Hope takes a classic pose after missing a putt.

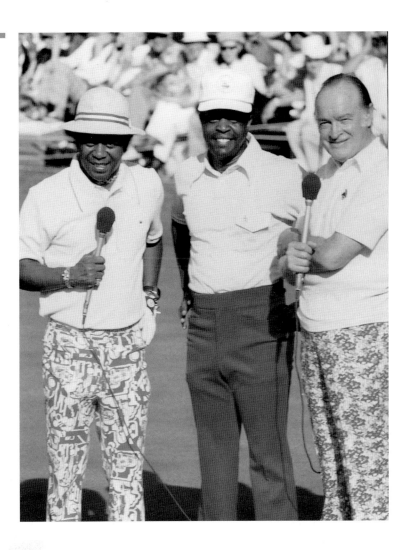

Bob Hope and comedian Flip Wilson, left, interview PGA professional Lee Elder at Hope's Desert Classic tournament. Note their signature patterned pants.

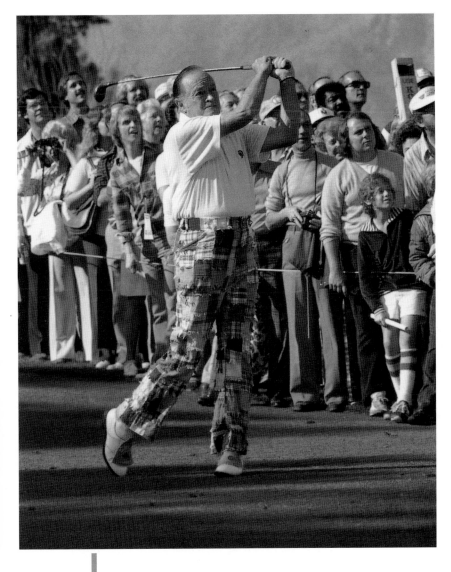

Hope's sense of golf fashion changed over the decades, from the traditional of the 1950s to the loud plaids and patches of the 1970s.

each year. The Desert Classic is a favorite for golf professionals, amateurs, celebrities and U.S. presidents, including Eisenhower, Ford (who shanked many a ball into the gallery), Reagan and Clinton, all of whom have teed up at Hope's Classic.

A legend at Lakeside in his nineties, Hope is the only member allowed to drive his electric golf cart directly onto greens. He still plays a few holes every week.

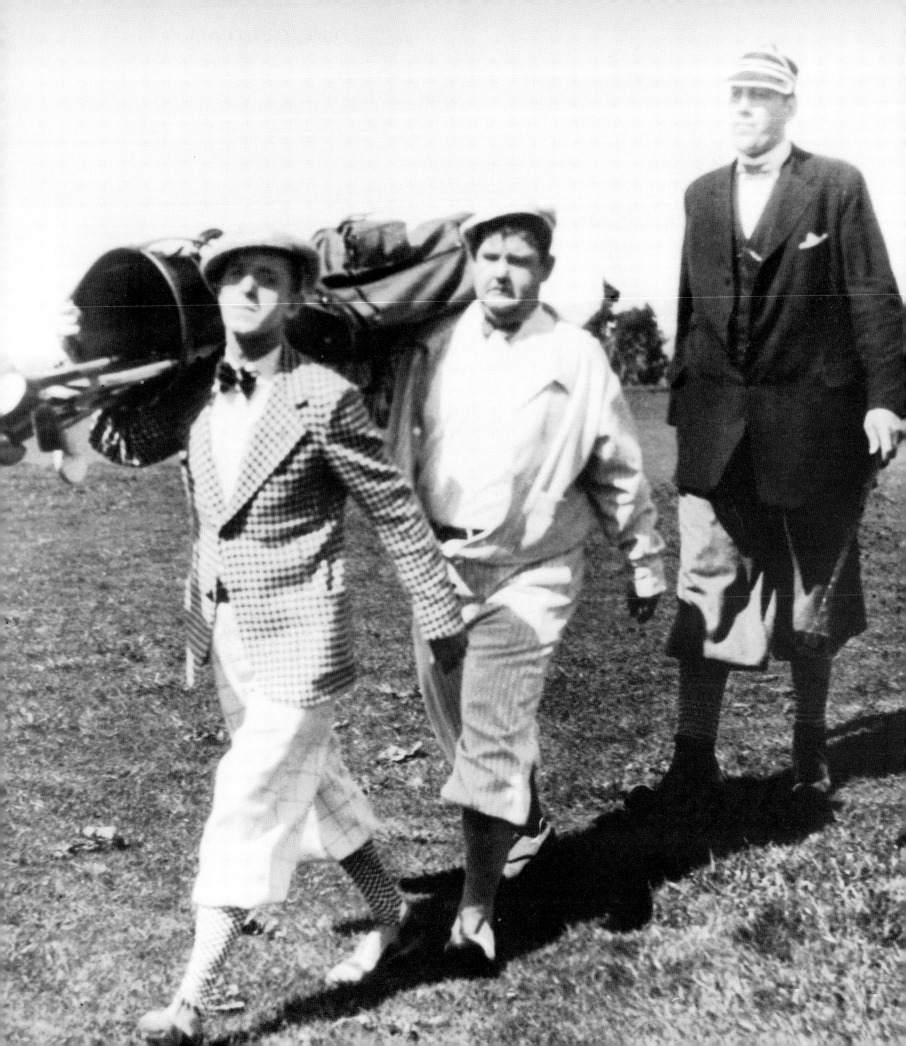

Oliver "Babe" Hardy
Golf Was His Other Partner

Few people know today that Oliver "Babe" Hardy, the portly half of the comedy duo Laurel and Hardy, was an avid golfer. His hefty frame and high handicap may have defied proper form, but he loved the game more than anything else.

Hardy first encountered the game of golf in 1921 when fellow actor and friend Larry Semon invited him to play. In John McCabe's biography of the comedian, *Babe*, Hardy describes his love of golf: "I loved it right from my first day on the links . . . I love it because it's social . . . nothing is quite like a good foursome of nice guys enjoying each other's company."

In 1931, Hardy joined Lakeside Golf Club and played frequently with other members including Bing Crosby and W.C. Fields, as well as Leo McCarey, who created the Laurel and Hardy team, and the duo's movie producer, Hal Roach. Every year Roach Studios held a golf tournament and Hardy regularly won the net prize. His comedy partner Stan Laurel was a casual golfer who preferred working on the duo's films and future projects to running over to Lakeside for another round.

However, the jolly Hardy, who earned the nickname "Babe" because of his round, soft baby-face, had other reasons for spending time on the greens. His wife Myrtle's nasty drinking habit made for a troubled home life, so playing a few holes at Lakeside provided him with a much-needed haven.

Funnyman Oliver "Babe" Hardy, right, displays his caddying skills to film star Don Ameche at Lakeside Golf Club. Hardy loved the game so much that he spent more time at the golf course than at home.

It took both Laurel and Hardy to caddy for this golfer in the 1928 Hal Roach comedy Should Married Men Go Home?

At Lakeside, Hardy, Maurie Luxford, rear, and actor Guy Kibbee, right, get some last-minute pointers from pro Johnny Goodman at a World War II Victory Tournament. Hardy, though lacking good form, participated in many Victory Tournaments during the war.

Known as graceful swinger for a big man, his weight sometimes got the better of him. One day he was on the 5th hole at the old Hollywood Country Club in Sherman Oaks. The 5th was a 140-yard par three, with a dramatic slope into thorny brush and the tee area some forty feet higher than the green. Hardy shanked a few shots and then re-hit. On his third swing he took a mighty cut. This spun him around and his club caught a water bucket behind him. He tripped himself and tumbled down the steep incline, just like a scene from one of his famous comedies. Hardy came up a few minutes later full of thorns and dirt and his pants split down the backside. After dusting himself off, the good natured comedian said: "I'm glad Laurel wasn't here to see this, I'd never live it down."

On another morning at Lakeside, Hardy again shanked a drive so bad off the tee it killed a rattlesnake. When his caddy ventured into the rough to retrieve the golf ball, he found the rattlesnake belly-up.

In 1935, Hardy reached the finals in the last flight at Lakeside Golf Club. His opponent was the actor Adolphe Menjou. Both Hardy and Menjou were high handicappers. The finals had to be postponed several times, and Menjou accused Hardy of avoiding him. In the meantime, a lot of betting action was being built around the Lakeside clubhouse, upwards of seven thousand dollars. Hardy won the match by a few strokes, but neither golfer broke 100.

Johnny Weissmuller
Tarzan of the Fairways

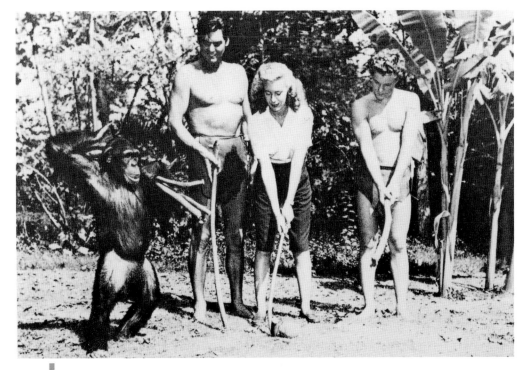

Johnny Weissmuller and his Tarzan cast get swing tips from Cheetah. Weissmuller, an Olympic swimming champion, adopted golf as his second sport. When he was playing well, he often gave his famous Tarzan yell.

Best known for playing the role of Edgar Rice Burroughs' famed jungle boy, Tarzan, Johnny Weissmuller was also an Olympic swimmer and one of the better celebrity golfers of his era. A member of the board of directors at the California Country Club, and a member at Lakeside Golf Club, Weissmuller was as serious about his game as any player in Hollywood. And nothing, not even a brush with death got in the way of his playing a golf game.

The swimmer-turned-actor once had a close call on the way to a tournament on Catalina Island, a favorite weekend retreat for Hollywood golfers. Napping on the deck of his 55-foot sailboat, Weissmuller was washed overboard by a rogue wave. He yelled like Tarzan but no one heard him. He could see the lights of Catalina's village of Avalon about five miles in the distance, so he began to swim towards it. In the meantime, the sailboat's captain noticed that Weissmuller was missing, pulled the boat around and searched frantically. Distraught, the captain rushed to Avalon for help. When the boat arrived at the port, Weissmuller was sitting on the dock. "Where the hell have you been?" he asked. Although a bit worn out from his late-night swim, Weissmuller went on to win the tournament the next day.

In the late 1950s, Weissmuller, Bob Sterling and Buddy Rogers were invited to participate in a celebrity golf tournament in Havana, Cuba. Cuba had yet to fall to Castro's forces, but the rebels controlled the hill country. For the event, the Batista government provided the celebrity golfers with armed escorts. On the way to the golf course, rebels toting guns stopped Weissmuller's group. Outgunned, the bodyguards surrendered their weapons and waited in silence. Weissmuller got out of the car, beat his chest and did his famous Tarzan yell. The stunned rebels surrounded him saying: "Tarzan, Tarzan, *bienvenida de Cuba*, Tarzan!" Weissmuller signed autographs and soon the troops let the famous travelers go play in the tournament.

Weissmuller's final years ended the way of many celebrities. With a weak head for finance, Weissmuller fell victim to promoters' and managers' shaky investment schemes. In the early 1960s, Weissmuller was forced to sell his Lakeside Golf Club membership to pay debts. He ended his career in Las Vegas, living in a rented apartment, working as a greeter at Caesar's Palace and playing very little golf.

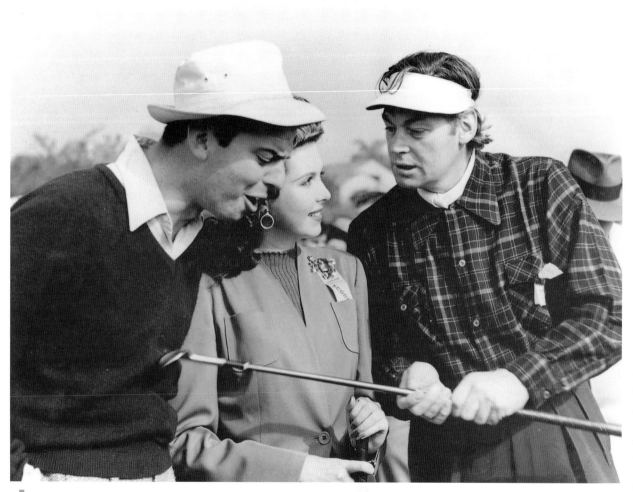

Actors Ray Bolger, left, Ann Miller and Johnny Weissmuller discuss their choice of golf accoutrements at a Victory Tournament. Weissmuller won over fifty trophies in his days at California Country Club, Lakeside Golf Club and numerous celebrity tournaments.

W.C. Fields
Blasting Golf Balls . . . and Ducks

As one of Hollywood's first film comedians to use golf as an integral prop in his act, W.C. Fields also possessed an equal penchant for playing the game and imbibing his favorite spirits. Whenever the two could be enjoyed simultaneously, it was all the better. And just so he didn't have far to go for either, he lived on Toluca Lake, directly across from Lakeside Golf Club where he played regularly. Fields always kept a hip flask in his golf bag. When asked what was in it, he always replied, "Oraaange juice."

At Lakeside one morning, Fields and three friends were about to tee off when the comedian excused himself and headed for the locker room. His partners saw a golden opportunity to play a joke on the master. While Fields was away, they replaced the vodka in his flask with orange juice and put it back in his bag. Fields soon returned and teed off. After hitting his drive, Fields grabbed his flask and took a belt. He spit out the drink and exclaimed, "Somebody put oraaange juice in my oraaange juice."

Fields loved the location of his home overlooking the club's lake, but had about as much tolerance for the duck population as he had for children. Early every morning the ducks from the lake would waddle up onto his lawn, frequently waking him with their loud squawking. With an active party schedule, Fields slept late. Many mornings, a hung-over Fields woke up to the squawking ducks, chased them off with his cane, but to little effect.

It became such a ritual that Lakeside members waited on Sunday mornings to view the "Fields Follies." On one particular Sunday, however, things turned out differently. As the members watched again with anticipation, Fields burst through his back-door in his underwear and instead of waving his cane, he bran-

A young W.C. Fields displays his swing at Lakeside Golf Club. Although not a top player, Fields was much sought after as a partner for his humor, quick wit and ever-present hip flask filled with "oraaange juice."

dished a double-barreled shotgun. Fields took aim and shot every last duck that was waddling on his lawn.

"That will serve you right," he said as feathers flew and members watched in horror. With his duck problem solved, Fields waved to his stunned audience and went back to bed.

Neither patience nor honesty were Fields' strongest attributes. At Lakeside one morning, Fields whiffed his drive on the first tee and said in his unmistakable twang: "Saaay, one of my better shots." He then walked out in the fairway two hundred yards, dead center, and had his caddie, Scorpy Doyle, drop a ball and pretend that he had found it.

Doyle exclaimed: "Here it is."

"Mighty fine drive, if I do say so myself," Fields replied.

Once when playing a match with fellow comic Buster Keaton, Fields bet the sad-eyed Keaton a dozen golf balls that over the course of the round Keaton would not make a single par. The match started and neither played well. Fields used his hip flask more than his putter. At the 18th hole, Keaton hit two nice shots and made a long putt for a par 4. He immediately demanded his dozen new balls. By then, Fields was feeling pretty "relaxed" and had forgotten about the bet. Amused, he slurred, "My, oh my. To think it only took you 18 holes to make a par, mighty fine play, Buster."

W.C. Fields relaxes at his favorite hole, the 19th, outside the Men's Bar at Lakeside Golf Club. During Prohibition, Fields ferried liquor from his private collection by boat across Toluca Lake to the club, much to the delight of thirsty members.

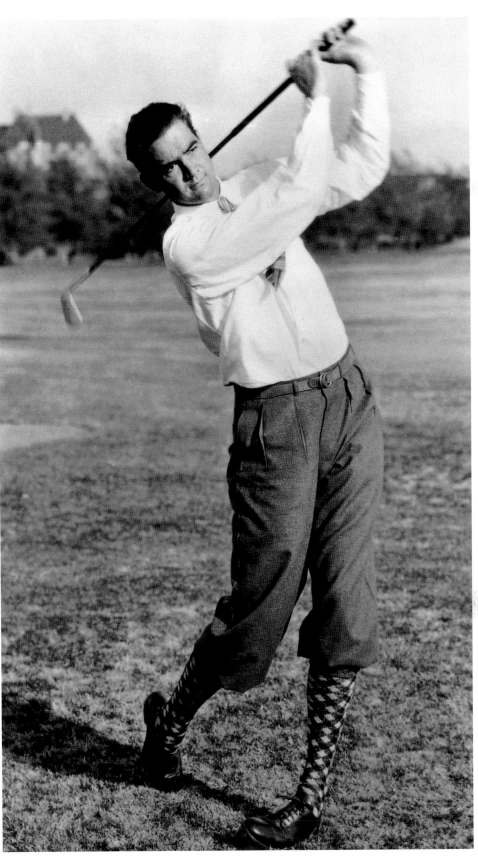

Howard Hughes
Gentleman Golfer

When Howard Hughes, the eccentric millionaire, set his mind to something, there was no stopping him. He proved this in 1937 when he sought a golf date with the young beauty, Katharine Hepburn.

When Howard Hughes began courting Hepburn, golf played a featured role in their affair. One afternoon, Hepburn was playing golf at Bel-Air, her home club. During the course of her round, Hughes mysteriously appeared at the 9th hole, and together they played the back side. The worth of retelling the story is not when Hughes arrived on the golf course, but how.

As with many Hollywood stories, accounts of this meeting differ slightly but the outcome is always the same. It seems that Hepburn was playing with Bel-Air club pro, Joe Novak, and was ready to tee off on 9. Then, from the north, a small airplane emerged just above the trees, circled and landed on the fairway. Hughes jumped out of the plane with his golf clubs and asked if he could finish the back nine with her. Hughes had been pursuing Hepburn for some time and felt the

The ever-stylish Howard Hughes worked on his golf game incessantly from his teens into his thirties. He was one of the first to film his practice sessions. Hughes gave up the game when his instructor told him he could never win the U.S. Amateur.

39

flashy entrance might impress her. Hepburn consented to his request and finished the round with the brash young aviator.

Bel-Air's members were not pleased with Hughes' stunt and chained his plane to a tree just off the fairway. Hughes paid a small fine for damaging the course and was reprimanded by the club's president. Angered by the well-deserved scolding, he left Bel-Air, never to return.

He did, however, continue to see Hepburn and for a time they moved into his house off the eighth green at the Wilshire Country Club, where the illustrious couple was frequently seen playing throughout 1936 and 1937, before Hepburn moved east in 1938.

With a lot of hard work and steady play, Hughes had become an accomplished golfer in his own right. At one point in his golf career, he played to a 2 handicap, low enough to do well in serious competitions. Although he was no longer welcomed at Bel-Air after his aerial stunt, he belonged to several clubs in and around Hollywood, including Los Angeles Country Club, Wilshire Country Club and Lakeside Golf Club.

Hughes' wealth, however, was the envy of many. Whenever he played golf he usually had a wager on the game. He was an honorable man about betting. He often played against better golfers and gave strokes for which he should have bargained harder. Hughes loved the challenge. He considered it part of his training to become a top-flight amateur player.

In order to achieve that goal, Hughes had several steady playing partners including George Von Elm, the one-time U.S. Amateur champion. The two had played together weekly for years, ever since Hughes was a seventeen-year-old playing at the Rancho Golf Club. Von Elm made a living off of Hughes, winning thousands from him monthly. Hughes considered the drubbing the price of learning competitive golf.

Finally, one day Hughes beat Von Elm. Von Elm, not a rich man, was forced to write a check for five hundred dollars, all the while cussing and complaining about Hughes' inflated handicap. After handing over more than five hundred dollars a week to Von Elm for years, Hughes simply said: "Well, George, if you feel so bad, I'm going to tear this check up, and it'll be the last time we'll play golf." Hughes ripped up the check and never again played with his old partner. For five hundred dollars, Von Elm gave up a steady income.

For a man of his wealth, Hughes was often ribbed for not gambling enough. The needling finally got to him one day at Lakeside. He walked into the bar where some members began to goad him into making a bet. Looking around the room for a volunteer, Hughes proffered: "I'll roll the dice and you roll the dice, whoever has the higher roll wins. Here's a check for one hundred thousand dollars to cover the bet." No member would take the bet and they never bothered Hughes again about his ability to place a wager.

In 1928, Hughes' production company was making the war movie *Hell's Angels* with Jean Harlow. While Hughes was on the practice tee at Lakeside Golf Club, an armada of World War I fighter planes from the movie roared overhead. The stunned members looked to the sky in awe, while Hughes kept his concentration and continued to hit practice balls.

On and off the golf course, the flashy millionaire was known to be a man of vision. Ahead of his time, Hughes would often set up three to four cameras on the practice tee and film his golf swing. A golf pro analyzed the film and gave his recommendations to Hughes. Today, video evaluation of a golfer's swing is a standard practice at driving ranges.

Many of the stories about Hughes are legend, truth and half

As a young bachelor, Howard Hughes lived in a Spanish villa off the 8th green at Wilshire Country Club. The rambling villa still stands today as a tribute to the once-grand times of 1920s Hollywood. Hughes was legendary in Hollywood's golf circles. For example, one day he was playing a big-money match with friends at the club. As they approached the 8th green and began putting their balls, Hughes gave a silent cue and a naked woman appeared on his balcony. Hughes' opponents, crying foul, were so distracted by the naked woman that they missed their putts. Hughes denied that he had anything to do with the display and he won the bets. In later years, executives from Hughes Tool Company donated oil-drilling bits, known as rock bit cones, to the club for use as tee markers, a reminder of the colorful heritage Wilshire and Hughes shared.

truth, all difficult to substantiate. However, one that remains consistent is why he gave up golf. Ever the perfectionist, Hughes had spent many months practicing with Willie Hunter, the renowned pro at Riviera. Finally, Hughes asked if he had a chance to win the U.S. Amateur Championship. Hunter told him it was unlikely.

Upon hearing that prognosis, Hughes quit the game and never played again.

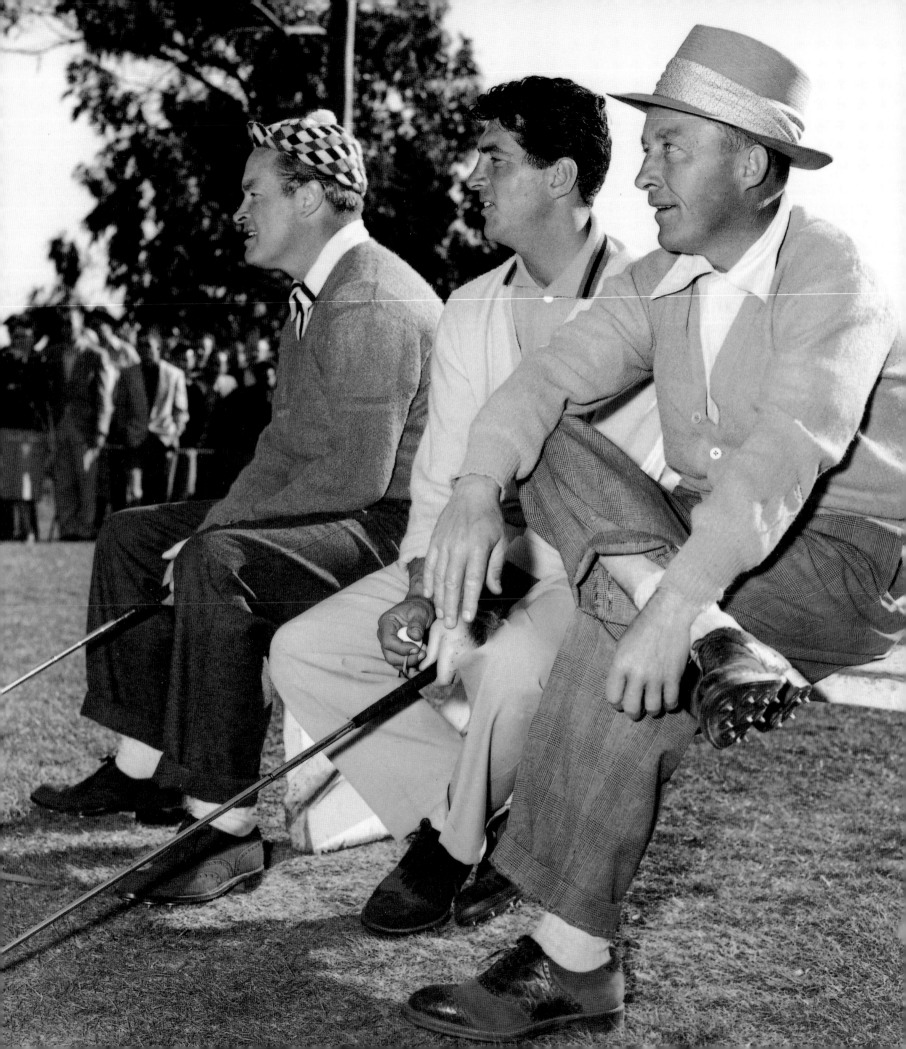

Dean Martin
Only on Days that End in Y

Dean Martin first arrived on the Hollywood golf scene in 1948. It was the same year that he and his comedy partner Jerry Lewis moved west and began their successful association with Paramount Pictures, in a classic coupling of the straight man and the clown.

On the golf course, the straight man was an accomplished golfer by Hollywood standards, often shooting in the 70s. At Bel-Air, Martin shot a 72, his best round on the course. Instead of playing with high-handicap celebrity friends, Martin opted for his regular rounds to be played with top amateur golfers. His group included top southern California players Art Anderson, Fletcher Jones, Bill Ransom and Canadian Amateur champion Johnny Miles. He enjoyed the challenge and camaraderie of great players, who also helped him with his game. But, even shooting 72, he still lost four hundred dollars to Anderson, who frequently scored in the 60s.

People loved to be around Martin on and off the course because of his low-key demeanor and wonderful sense of humor. He could be found in the Bel-Air Card Room with the guys after an afternoon round. He endeared himself to celebrities and golf regulars alike. This was illustrated one day at Bel-Air when he and

Representing a new generation of golf in Hollywood, Dean Martin is flanked by Bob Hope and Bing Crosby as they wait to tee off during an exhibition match.

Anderson were playing with a businessman from Detroit, Al Mondella. Mondella did not know he was paired with Martin, one of the biggest stars in Hollywood. He was dumbfounded when he stepped up to the first tee and was greeted by his idol. Mondella kept Martin and Anderson amused for the round with his awful play and irreverent humor. A week later, Martin and Anderson were playing in a pro-am tournament in Rancho Mirage, near Palm Springs.

When they approached the first tee, Mondella was there with friends. Martin decided to play a little joke. He went straight up to Mondella, in front of his friends, and said: "Al, hi, I'm Dean Martin. You may not remember me, but we played golf together last week." Mondella stammered hello and tried to introduce the famous singer to his friends from Detroit, but could barely get words out. Dean graciously introduced himself and asked if they would like to follow him around during the tournament. The group of men, speechless, nodded that they would.

Dean's love of golf occasionally got him into hot water around the house. His wife Jeanne complained that he spent too much time on the golf course, neglecting the house and yard. One day as he was about to go to the course, she finally lost her temper and gave him the proverbial piece of her mind.

He got the message and as he headed out the door, he spotted a landscaping truck parked across the street. He approached the landscape crew and showed them some trees he wanted trimmed. They agreed to cut them back.

Later that afternoon, when he returned from the golf club, he showed Jeanne the trees. He said, "Honey, I had those trees trimmed today."

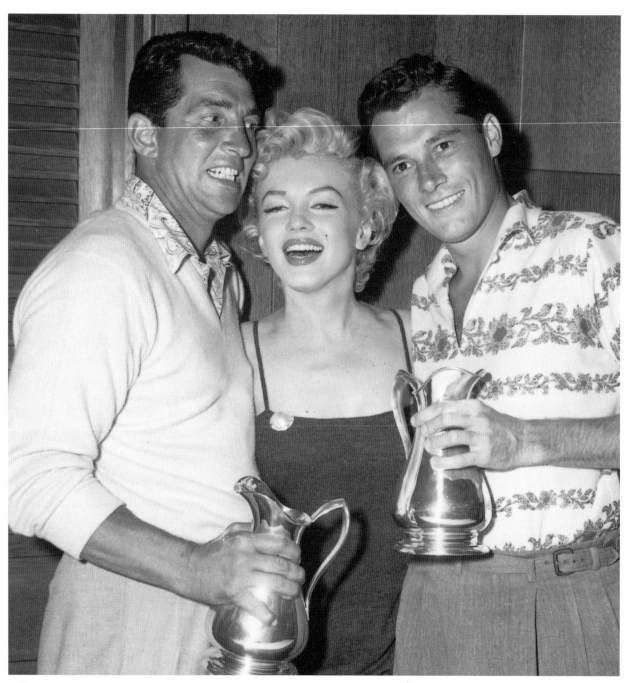

Dean Martin and Nicky Hilton, right, receive trophies from tournament queen Marilyn Monroe after winning a celebrity match at Hillcrest Country Club. Hilton was married to Elizabeth Taylor at the time.

"That's nice, Dean, but those aren't our trees. Those are the neighbors'," she replied.

On weekend mornings, Dean would play at seven o'clock, which meant he would be in bed by ten the night before. One evening his wife invited friends over for a party. Dean didn't care for parties, but finally gave in. The party was on a Saturday night and several celebrity couples arrived, including Mr. and Mrs. Don Rickles and the Sammy Cahns.

At exactly ten o'clock, Dean snuck upstairs and went to bed; he wanted to be fresh for his golf match the following morning. At midnight, Jeanne rushed upstairs and woke Dean, saying the police were downstairs. The problem was soon resolved. The next morning at Bel-Air, Martin admitted to his golf partners that he had called the police himself. "Officer," Martin said on the phone to the policeman on duty, "those noisy Martins are at it again!" Dean did not like his golf rest interrupted.

Golf even seeped into his life as a performer. On his weekly television show, every time he mentioned Titleist golf balls, the company sent him a gross of new balls. Martin never received

money for his plugs, just the balls. One day at Bel-Air on the 18th hole, Martin pulled out a dozen brand new Titleist balls and hit them into the creek. His partner asked him what he was doing. Martin replied, "I gotta get rid of these damn balls somehow."

In the mid-1960s, Martin and some backers wanted to create their own country club in Beverly Hills, off Benedict Canyon Road. The seed money never came through and the project was halted. So Martin continued to play at Bel-Air. He lived nearby on Mountain Drive, and after a five-minute drive to the club, he grabbed his clubs and a caddy and was off for a quick round.

Some people said that Martin left Bel-Air Country Club after the greens were rebuilt, leaving temporary greens for a lengthy period of time, others say that he stopped playing there when the club refused to give him his own parking place. His old buddy Anderson insisted the explanation was simpler: Martin fell in love with the course at Riviera and joined, but retained his membership at Bel-Air, frequently dining there on Sunday evenings. Yet, undeniably, his one great joy was golfing at Riviera, which he did every day of the week.

Eventually, Martin moved to a house adjacent to Riviera, where it was even more convenient to play. Unlike many golfers who had regular early morning tee times on weekdays, Martin preferred noon. He stayed around the house, sang a few songs and then headed to the club. When he was taping his television show on Friday afternoons, Martin played a noon match before driving over the hill to NBC Studios in Burbank. Some said he would not rehearse prior to taping so the material would stay fresh. Others said it was so he could get in another round of golf.

Although Dean Martin had a well-honed reputation as a big drinker, close friends always insisted it was only part of his act as a smooth lounge performer. He was once interviewed after completing his round at the Crosby Pro-Am in Pebble Beach. In keeping with his reputation, Martin replied, "I didn't make a par until the 5th hole, then I broke out the vodka and played great the rest of the way. Those Russians have all the answers."

Dean Martin whacks a drive at the 1963 Frank Sinatra Charity Tournament in Palm Springs. Martin was one of the best celebrity golfers and a fan favorite at the many pro-am tournaments held in Hollywood and Palm Springs during the 1950s, 1960s and 1970s.

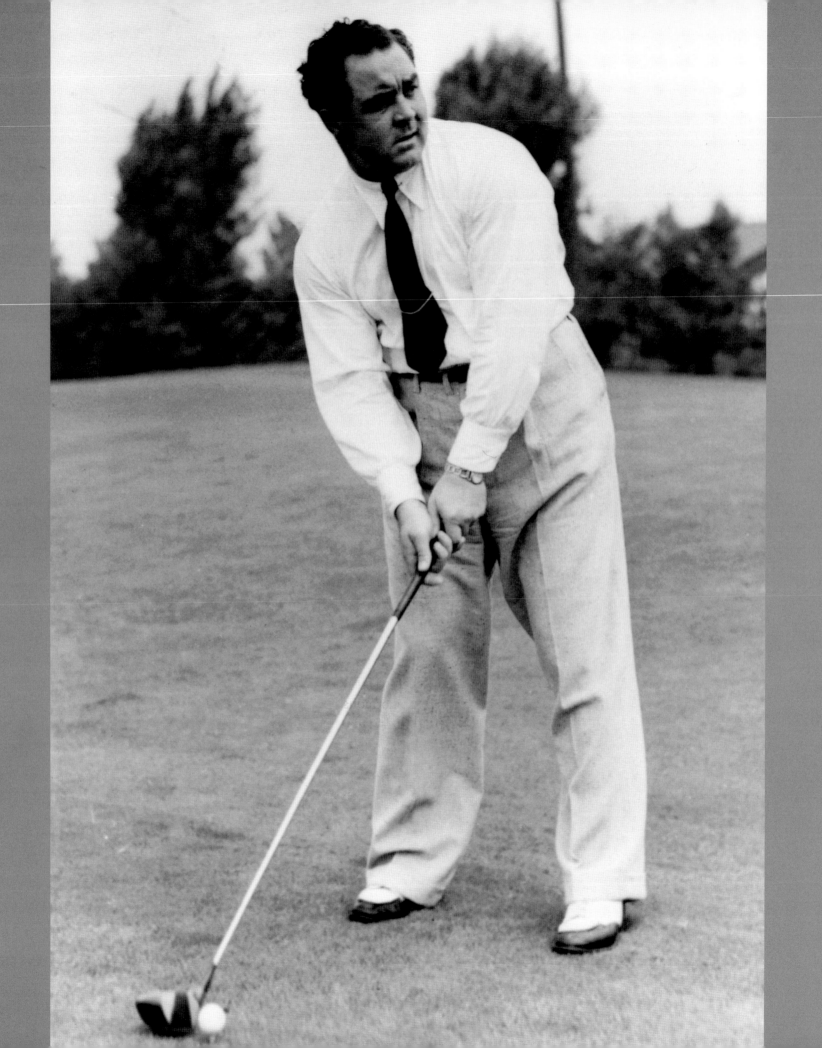

John Montague
A Mysterious Legend

In 1930, a mysterious figure emerged on the golf links in southern California named John Montague. Celebrities and others got their first look at Montague's powerful swing at California Country Club and Rancho Golf Club — and what they saw was unlike anything the world of golf had seen before.

Before long, legend grew that he was the longest golf ball hitter in the world and perhaps the first great trick shot artist. In 1933, with his reputation growing, Montague became a member at Lakeside Golf Club — Hollywood's golfing playground. He dated Paulette Goddard and became a regular player with low-handicappers Richard Arlen and Bing Crosby. He was best friends with Oliver Hardy and played golf with Katharine Hepburn, Randolph Scott, Dick Powell, Fred MacMurray, Johnny Weissmuller, Fred Astaire, Ruby Keeler and other celebrities.

Montague, a huge man with enormous arms, liked running with the fast Hollywood crowd, and Hollywood liked the idea of running with legends. Montague had money, though he never worked. Where his came from was a mystery. Speculation abounded, with most people convinced that he had mining interests in Arizona, or perhaps Death Valley.

Standing a little over six-feet tell and weighing two hundred fifteen pounds, Montague performed amazing feats of strength. On one occasion, Johnny Weissmuller and Montague were out on the town and a traffic altercation occurred. A man jumped out of his car and accused Montague of cutting him off. The fellow

John "Mysterious" Montague teeing it low with his custom-made, super-heavy eighteen-ounce driver, forerunner of today's Big Bertha metal driver. Sportswriter Grantland Rice considered Montague the greatest golfer ever to play the game. Many of his drives exceeded four hundred yards.

then laid into Montague with numerous epithets. Weissmuller observed the show and waited for Monty's response. Montague walked over to the man's Lincoln, picked it off the ground and dropped it so hard that a headlight fell off. The guy turned white, jumped back into his car and took off. Weissmuller proclaimed that Montague was the guy you wanted in your corner in a bar fight.

Once, after a charity match in the 1940s, Weissmuller joined Montague in his hotel room for drinks. Montague asked Weissmuller to open the window and place a cocktail glass under it to keep it open. He then took a 2-iron and began to chip balls through the narrow opening into the street below, with the ball never once touching the glass. Traffic dispute, bar fight or charity match — Montague was always the performer.

Sportswriters such as Grantland Rice and Joe Williams fanned Montague's legend. Rice once wrote that the National Amateur Golf Championship's winner would not be the best amateur golfer because John Montague had not entered the competition. In 1935, the nationally syndicated Williams called Montague: "the most talked about golfer of the year." His golf skills were unsurpassed in his day, and perhaps even now:

Montague was one of the country's best trick-shot artists. He often purposely buried his ball under a flap of rough, as he did here, and then used a 3-wood to hit the ball within a few feet of the hole.

- His drives would average between three hundred and four hundred yards
- With a 2-wood, he hit completely buried balls out of sand traps to within inches of the cup
- He consistently hit balls from over one hundred yards to within a few inches of the hole
- His putting was deadly accurate and he routinely drained up to a dozen balls in a row from twenty feet
- He used a heavy, eighteen-ounce driver — as big as, or bigger than, the giant oversized Big Bertha drivers of today
- At Pebble Beach's famed five-hundred-sixty yard 14th hole he used a driver, 1-iron and hit it fifty yards beyond the green

Despite his prowess, Montague never went on the professional tour, which was low-paying and not very glamorous. He shunned the spotlight and rarely played in public. He refused to have his picture taken and if he caught someone snapping it, he grabbed the camera, ripped out the film and threw several hundred dollars at the photographer. Montague's on-course heroics and air of mystery, along with countless newspaper and magazine articles generated by Rice and others, catapulted his name into the national limelight. The publicity-shy Montague became a national phenomenon

Montague invented the "bat, shovel and rake" gambit featured in the movie Tin Cup *(1996). Here he putts using a shovel handle. A talented baseball player, Montague could hit a golf ball three hundred yards with a bat.*

despite his efforts at anonymity.

In Los Angeles, he played regularly with Crosby, who had reduced his handicap to a respectable 2. Though Montague was generous in giving away strokes to his opponents, he rarely lost. After winning a match with Crosby at Lakeside one afternoon, Crosby complained that Montague had not given him enough strokes. A bemused Montague bet Bing five dollars a hole that he could beat him using only a baseball bat, a rake and a shovel. Crosby laughed and was ready to cash in on a fool's bet. They went to the 1st tee, a par 4. Montague tossed his ball in the air and with the baseball bat, smacked it three hundred yards down the fairway into a green-side bunker. Astounded but unfazed, Crosby made his standard smooth swing and drove his ball down the center of the fairway. His second shot came to rest about thirty feet from the cup.

Montague, using his shovel this time, played his bunker shot to about twelve feet from the hole. Crosby's birdie putt rolled about four feet past the cup. Montague gave him the rest of it for

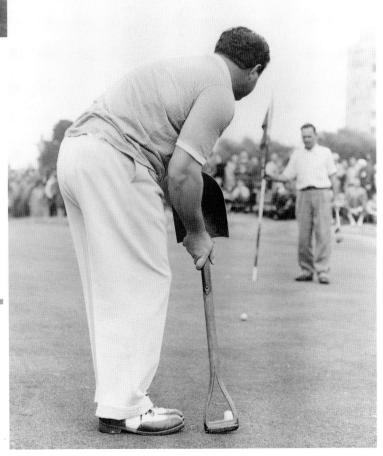

par. Then, using the rake as a pool cue, Montague drained his putt for a birdie. A disgusted Crosby tossed a five-dollar bill his way and walked back into the clubhouse. This bet between Montague and Crosby was inspiration for a similar challenge in the 1996 film *Tin Cup*.

A favorite Montague "handicap" was to give opponents the option to hit as many balls as they wanted. His rivals thought they would pull a fast one and accepted. However, after nine holes, they had hit a couple of hundred shots and were too exhausted to be competitive on the back nine. Monty struck again!

Bing Crosby called Lakeside "John Montague's backyard." At one match, Montague gave veteran actor Jack Oakie 65 strokes and still beat him. There was talk that several of Lakeside's members, including Crosby, Weissmuller and Arlen, were prepared to put up a large sum of money (some reports say fifty thousand dollars, while others claim double that) to back Montague in a match against the nation's top player, Bobby Jones. The Montague-Jones match never materialized, much to the chagrin of Crosby, Weissmuller and Arlen, who felt they could have cashed in big with Montague.

At one time Montague played former U.S. Amateur champion George Von Elm in a series of matches in Palm Springs. After playing more than six hundred forty holes of golf, Montague set four course records and carded a 61. Following the matches, Von Elm proclaimed Montague as "the greatest golfer in the world."

Though he was a living legend, John Montague rarely gave an interview. Despite the numerous articles written about "The Mysterious Montague," a close-up picture had yet to be published. Finally, an enterprising photographer was able to get a photo of Montague and somehow that photograph made its way east and into the hands of a few upstate New York Police detectives. Montague looked a lot like a wanted criminal, one LaVern Moor from Syracuse.

Moor was accused of participating in a hijacking and the robbery of a small roadhouse in Essex County. Someone was shot and killed. Police found LaVern Moor's golf clubs in the trunk of the car used in the robbery.

When manslaughter charges were filed against Montague, he admitted he was LaVern Moor and headed back to New York to meet his accusers. While he was in New York, stories multiplied about the young Moor, who turned out to be an excellent athlete in Syracuse. Records showed he was born in 1906. As a youth he excelled in golf and football and had a menacing fastball in baseball. In 1928, he went to spring training in St. Petersburg, Florida, and tried out for the New York Yankees and the Boston Braves. He did not sign on, but he made fast friends, gambled, hustled at golf and caroused with Babe Ruth. The local stories stopped around 1930, the same time Montague arrived in Los Angeles.

Several Lakesiders, including Bing Crosby, Gary Cooper, Guy Kibbee and Oliver Hardy, rushed to New York to testify in his behalf. Crosby posted the necessary ten-thousand-dollar bond for bail and Montague rented a sixteen-room "palace" directly across the street from the courthouse where he could entertain his celebrity cronies.

At the trial, Crosby, Hardy and the others vouched for their pal Montague's integrity. They said he was a kind and generous gentleman, who would never harm another individual. His mother testified that he was at home in Syracuse at the time of the robbery. The jury sided with Montague, although the judge admonished Montague in his briefing and said that he felt justice had not been served.

After all was said and done, Montague's celebrity status ironically saved him from prison.

Montague was ready to sign a movie deal for one million dollars with Everett Crosby, Bing's brother, shortly after the trial. The movie contract never materialized, however, and the fallen hero made several instructional golf short films and played in an international golf exhibition tour. He became the country's premier golf trick-shot artist.

On one occasion, in Flushing, New York, he was paired with golf champ Sylvia Annenberg against Babe Ruth and Babe Didrickson. Ten thousand spectators invaded the course, a crowd so big that the match was canceled after nine holes, for fear that players or spectators would be trampled.

As the stories of Montague receded in the 1940s, he settled in as a pro at the California Country Club, a club run by Fred MacMurray, Johnny Weissmuller and agent Bo C. Roos. In addition to a job, they gave him a home to live in. He also played in several war bond exhibition matches with Bob Hope, Bing Crosby and other Hollywood celebrities. Montague often gave trick shot exhibitions afterward, featuring his rake, bat and shovel routine.

After his exhibition tours stopped, Montague remained in Los Angeles and kept himself in relative obscurity. He frequently picked up bar tabs at famous Hollywood haunts such as Musso & Frank, Perino's or the Brown Derby. At Christmas, he would see to it that caddies were well taken care of for the holidays. However, there were conflicting reports detailing a violent temper with both men and women. He was banned from many golf

courses in Palm Springs for hustling local members, and stories circulated about him picking fights while drinking and carousing.

Once the mystery surrounding Montague was solved, his legend and his notoriety faded from the public eye. An auto accident in 1955 severely limited his mobility. Late in his life he would hang around the Studio City Driving Range in the San Fernando Valley, sharing his stories about the old times. Montague died in 1972, yet tales of the strongman and his powerful swing have lived on. Long after his death, Bing Crosby and fellow Lakesiders were still singing his praises as one of the greatest golfers to ever grace the greens.

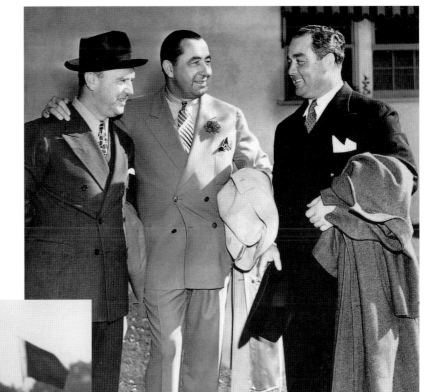

Actor William Frawley, left, golf professional Walter Hagen, center, and Montague share a laugh after a charity tournament. Montague's celebrity friends remained at his side during his manslaughter trial in New York. A jury that was won over by the Hollywood crowd eventually acquitted him.

Montague cracks a grin after winning the hole while putting with a shovel. Note the powerful Popeye-like forearms that helped him propel golf balls farther than anyone else in Hollywood.

Ladies of the Links
Hollywood's Best Female Golfers

Although golf was considered by many to be strictly a man's game, the ladies of the silver screen were not about to be left out of the picture. Over the years, Hollywood produced several fine female celebrity golfers.

The first female star to appear on a Hollywood course was Mary Pickford who, with her husband Douglas Fairbanks, joined Lakeside Golf Club in the mid-1920s. Although not a great player, "America's Sweetheart" was an avid golfer and was often spotted on links throughout California playing with the likes of young Ruby Keeler and Paulette Goddard, considered the best female golfers in Hollywood in the 1930s and 1940s. The actresses appeared in many of the Hollywood golf Victory Tournaments during the war years and played at Lakeside Golf Club.

The athletic and beautiful Katharine Hepburn began playing golf as a youth near her home in Connecticut. In Los Angeles she belonged to Bel-Air and owned a home along its 14th fairway. She would regularly shoot in the 80s from the men's tees.

Silver-screen siren Jean Harlow poses with her clubs at Riviera Country Club. Although not a member, Harlow was frequently seen at "Riv" and Lakeside Golf Club until her untimely death in 1937 at age twenty-six.

In 1938, after a succession of box-office flops, Hepburn returned to Connecticut to live with her parents. While there, she said, she played thirty-six holes of golf a day and was never happier. After a match, she would often wander over to the club-house and talk golf with the local pro.

Bette Davis, another rising star in the 1930s, was a member of Lakeside along with her husband, Harmon Nelson. One after-noon club pro Fred Murphy was giving the eager, wide-eyed actress a lesson. The lesson was not going well, and a frustrated Davis began breaking clubs over her leg. Her husband intervened before she could hurt herself. Davis calmed down and the lesson continued.

In the movies, sexy starlet Rita Hayworth set the screen on fire with her smoky eyes and curvaceous figure. When she appeared on the golf course, she not only turned heads, but showed herself to be an accomplished golfer, as well. In her husband James Hill's book, *Rita Hayworth - A Memoir*, Hill tells of the star's passion for golf. Prior to shooting *They Came To Cordura* in 1958, Hill and Hayworth took a vacation to Scotland for a month of golf. At the difficult Gleneagles Golf Club near Glasgow, Hayworth had a memorable round. Her caddy was in his eighties and decades before had caddied for pro Walter Hagen. She played well on the front nine and had a chance to break 90, something she had never done before.

Olivia de Havilland practices near Lakeside's Toluca Lake. De Havilland was one of a bevy of actresses who took up the game in the late 1920s and 1930s.

When she started the back nine, fog set in and it started to rain. Despite the conditions, Hayworth continued her strong play. By the par-4 18th hole, word had spread that Rita Hayworth was on the course and was threatening to break 90. A crowd of five hundred gathered on the verandah behind the 18th green. At the tee, Hayworth pulled her drive into the left trees. Luckily, Hayworth received a favorable kick off a hill, but she was blocked by trees ahead. Her caddy boosted her confidence with words of encouragement.

"You can do it, lass," he said. "Smooth and easy."

Heeding his advice, she took a deep breath, pulled out a 4-iron and made a nice, smooth swing. The ball found a clearing through the trees and came to rest five feet from the pin. Hayworth made her putt for a 1-under par birdie and a round of 87. As the crowd roared, a familiar-looking spectator approached her. It was her pal Bob Hope. "I wish I could attract a crowd like this," he said, hugging her.

In 1960, her husband was filming the movie *The Unforgiven* in Durango, Mexico. Hayworth was not working on the film but accompanied him to Mexico for the shoot. While there, she played golf daily on a small course near the film's shooting location. The tees and greens were smooth grass; however, the fairways were rough desert scrub. There she honed her game for desert golf that would come in handy later in Palm Springs where shr lived after retiring. In the mid-1970s, Hayworth was a frequent player in the Nabisco Dinah Shore Classic tournament, winning the amateur division on one occasion.

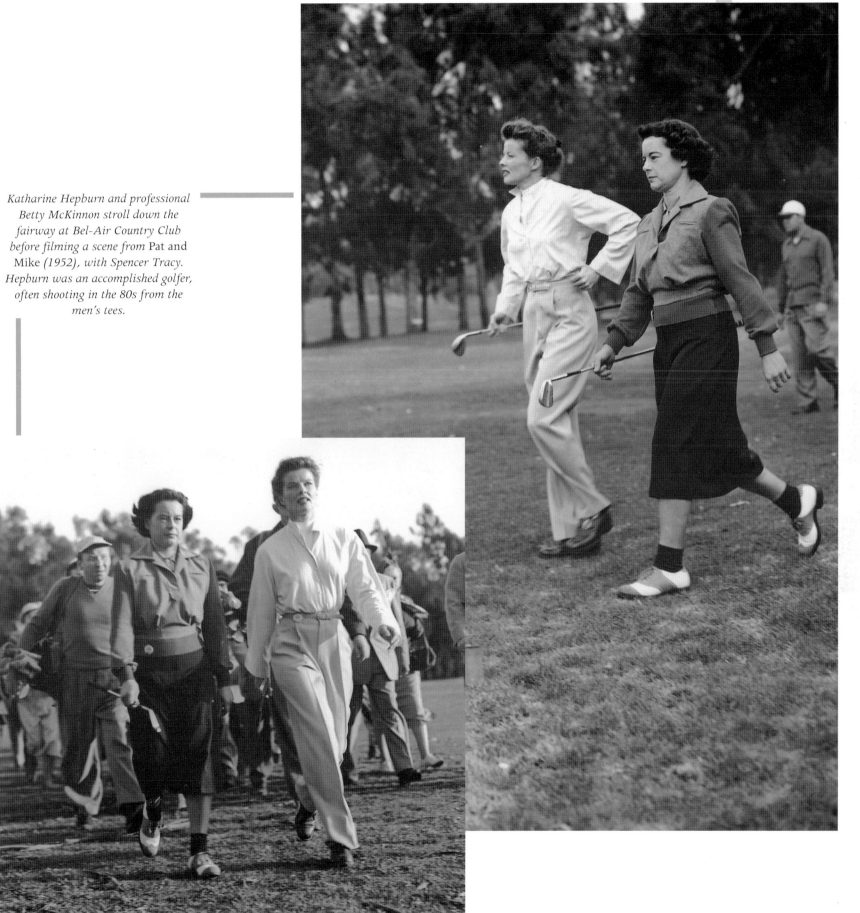

Katharine Hepburn and professional Betty McKinnon stroll down the fairway at Bel-Air Country Club before filming a scene from Pat and Mike *(1952), with Spencer Tracy. Hepburn was an accomplished golfer, often shooting in the 80s from the men's tees.*

Considering all the actresses who ever took up a golf club, no one is more closely associated with the game than Dinah Shore. Her devotion to the game was renowned. Hillcrest Country Club bent its "no single women" policy to allow Dinah's membership.

The singer and 1950s television star, was a startlingly strong athlete. Her participation in sports started early with the encouragement of her mother and doctor. Suffering from polio in her youth, she followed strict physical regimens that were prescribed to combat the crippling disease and keep her limbs nimble.

Shore was on the swimming team at Vanderbilt University and was also an excellent tennis player. She picked up golf late in life, yet took to the game quickly. Her best score was 87.

In the golf world, the singer was undoubtedly best known for her Nabisco Dinah Shore Classic tournament in Palm Springs. The event was inspired in 1973, when Shore played a round of golf with the cereal company's president David Foster during a sales conference. As they made their way around the links, a crowd of spectators composed of wives of the company's sales force followed. It occurred to Foster that a women's tournament would appeal to these female fans, so the Dinah Shore's Winner's Circle was born. The tournament continues today as the Nabisco Dinah Shore Classic and is a major event on the LPGA tour.

Dinah Shore took up golf late in life, but her natural athletic ability made her a fast learner. Her smooth swing and famous smile made the Nabisco Dinah Shore Classic in Palm Springs the top women's celebrity event on the Ladies Professional Golf Association tour.

Rita Hayworth watches as her drive lands on the fairway at the Nabisco Dinah Shore Classic. Hayworth was an avid golfer, who practiced regularly at driving ranges and courses in Los Angeles, as well as when making movies on location.

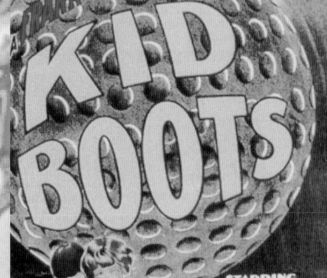

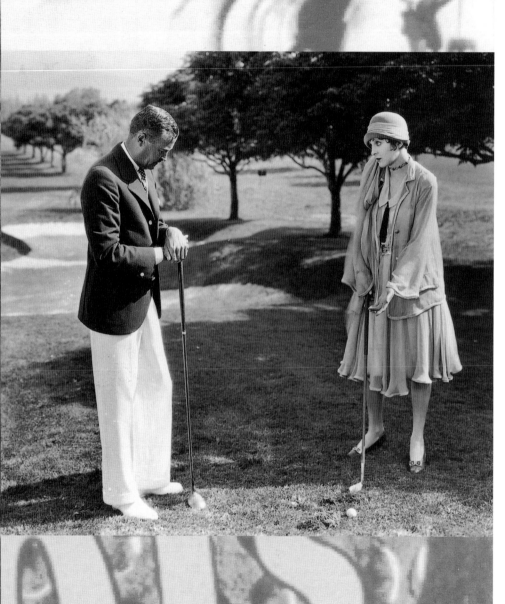

Chapter Two
Golf and the Cinema

Ever since the art and science of movie-making was conceived in the late 1800s, the topic of sports has been a natural subject for motion pictures. As early as 1896, the British film pioneer Brit Acres directed a one-reel comedy short called *Golfing Extraordinary, Five Gentlemen*, the first sports film on record. At the time, golf in England was the country's most popular sport with local matches drawing large crowds and golf stories appearing in literary and illustrated publications. On the other side of the world in Hollywood, however it would take almost two decades before a golfing story emerged in film.

For the most part, the genesis of golf movies lies in the comedic form. In its formative years, golf was not played by many Americans, nor could most people afford membership in expensive clubs to access the existing courses. So, golf was perceived as a sport that belonged to wealthy WASPs who fancied the exclusive country-club life. Most clubs had exclusionary membership policies — people were not admitted based on race, religion and sometimes occupation. Such ridiculous rules and the prevailing attitude of privilege that surrounded the game of golf was the perfect foundation for satire, set-ups and put-ons.

Directors of the early comedies took advantage of the game's follies. There was humor inherent in the stereotypic image of a silly game played by grown men dressed in gaudy clothes, chasing a tiny white ball with long sticks. Actors often took huge swings,

Director George Marshall hams it up with actors during the filming of a Bobby Jones instructional golf short. Jones was such a big star that other studios readily lent their top actors — W.C. Fields, James Cagney, Edward G. Robinson — to be in the Warner Brothers shorts.

Movie poster from the 1926 golf comedy Kid Boots *is the backdrop for a promotional photo from the film. Billie Dove, right, gets a lesson from William Worthington. The movie marked the film debut of Eddie Cantor after his huge success on Broadway.*

missed the ball and tumbled over. When stuck in sand traps, a comedian would dig in vain to extricate the ball from the trap. Errant golf shots ricocheted off trees and rocks and wound up beaning spectators and golfers alike. In the hands of skilled directors, writers and actors, golf could be a very funny subject.

From the early 1900s through the Roaring Twenties, British cinema continued making golf movies. P.G. Wodehouse, a popular author and fan of the sport, published four golf stories, *The Clicking of Cuthbert*, *Chester Forgot Himself*, *Ordeal By Golf* and *Rodney Fails to Qualify*, all of which were eventually made into silent-film shorts.

In America, the first golf films were made during Hollywood's silent era and were written as slapstick comedies. Exploiting the humorous idiosyncrasies of the sport were the industry's greatest comedians, including Buster Keaton, Harold Lloyd, Laurel and Hardy, Eddie Cantor and W.C. Fields. The notable exception was Charlie Chaplin.

Early American film pioneers Mack Sennett and Hal Roach, both avid golfers, made several comedies that captured the game's funny side on celluloid. Sennett was a member at Lakeside Golf Club and played regularly with Oliver Hardy and a young Bing Crosby. Roach was a longtime member of Bel-Air Country Club and was a fixture in the club's historic Card Room until his death, a few weeks shy of his hundred-first birthday.

Comedian Harold Lloyd was an accomplished golfer who built a par-3 course on his Beverly Hills estate. He was so serious about the sport that he hired Dr. Alister MacKenzie, famed architect of Pebble Beach and Augusta National, to design his private course. So when Hal Roach produced *A Foozle at a Tee Party* in 1915, Lloyd was the obvious choice as star. Lloyd's swing was perfect, a great counterpoint to the comedic body language he used to mock his favorite sport in this hilarious film.

Ingenue Joan Crawford frustrates her caddy George K. Arthur in the 1927 silent film Spring Fever. *Edward Sedgwick, a Lakeside Golf Club member, directed the MGM film.*

Spanky McFarland and chimp line up a shot in the 1936 Hal Roach production Divot Diggers. *Roach and fellow Hollywood artisans Mack Sennett, Jesse Lasky, W.C. Fields, Leon Errol and Richard Arlen formed the real "Divot Diggers" at Riviera Country Club.*

In the 1930 Mack Sennett film, Match Play, *professional golfer Leo Diegel negotiates a tough shot from the trees as actors Andy Clyde and Marjorie Beebe, along with professional golfer Walter Hagen and a caddy, look on.*

Billy Bevan, left, Mary Mabery and Vernon Dent create havoc on the links in the 1927 Pathé-Sennett film The Golf Nut.

Roach also produced *Divot Diggers* in 1936, which featured his *Our Gang* bunch wreaking havoc on the golf course. Lakeside member Robert McGowan directed the film, using his own personal experiences on the course to give golf sequences believability. In 1928, Roach put the Laurel and Hardy team on the golf course in *Should Married Men Go Home?* Although Hardy, suggested the film's golf theme himself, the foibles of golf were barely exploited. Instead, the comedy consisted of such antics as mud fights in water-filled sand traps. Critics lambasted the film, noting that the inherent challenges and frustrations of the game were enough to capitalize on the duo's slapstick brand of humor without extraneous set-ups. Roach's studios continued to produce golf comedies for years. In 1930, one of Roach's famed comedians, Edgar Kennedy, who belonged to Lakeside Golf club, directed the comedy *All Teed Up*, starring Charlie Chase.

Roach's rival Mack Sennett produced three notable golf comedies: *Golf Nut*, *The Golfers* and *Match Play*, which featured Lakeside member and comedian Andy Clyde trading jokes and shots with professional golfers Leo Diegal and Walter Hagen.

It was no accident that MGM also produced many of the early golf movies. President Louis B. Mayer and studio executive Eddie Mannix both enjoyed the game and saw its box-office potential. In 1927, MGM released the silent film *Spring Fever*, directed by Edward Sedgwick and starring Joan Crawford falls in love with a country club member, played by William Haynes, who wins the club championship.

Paramount Pictures had a big hit with the 1926 golf comedy *Kid Boots*, featuring Clara Bow and wide-eyed comedian Eddie Cantor. Notorious for her promiscuity, Bow created turmoil on the set with her sexual advances toward Cantor — a scandal that nearly destroyed his marriage. In Paramount's classic *The Big Broadcast of 1938*, W.C. Fields played a character who tries to break the world speed record playing golf by moving from shot to shot on a motor scooter. Filmed at Lakeside, just over the hill

from the studio, the movie also marked the debut of golf's other legendary comic, Bob Hope.

One of the game's most memorable comedies, *The Three Little Beers*, starred the Three Stooges. Today, images from this film of Curly, Larry and Moe can be found on T-shirts, coffee mugs, posters and golf head covers — golfing paraphernalia that has become a multi-million dollar industry for their heirs. Jules White at Columbia Pictures produced the Three Stooges shorts and played golf frequently with Louis B. Mayer at industry golf tournaments and Hillcrest Country Club.

Thanks to these rollicking comedies, by the mid-30s golf had become popular with the general public. People wanted to know more about the game and how to play it. That led legendary short-subject producer Pete Smith to film a set of instructional shorts as part of his Academy Award-winning series, *Pete Smith Specialties*. Smith, a serious golfer himself, produced *Trick Golf* in 1934 and *Golf Mistakes* in 1937.

Hollywood musical producers couldn't pass up the opportunity to set the game to music. In the 1938 musical *Carefree*, Fred Astaire choreographed a dance number that took place on a golf course. A member of Bel-Air Country Club, Astaire designed the dance number on the course's first tee. The scene was later shot at Bel-Air with the graceful hoofer dancing on the tee accompanied by a pianist. It was said that the many takes of Astaire's dance number forever damaged his sweet golf swing.

During World War II, few golf movies were made. However, in 1943 United Artists released *Don't Hook Now*, starring Bob Hope and Bing Crosby. The film primarily consisted of highlights from their famous celebrity golf Victory Tournaments with some musical numbers added.

In contrast to the lighthearted golf comedies, capturing the drama of golf has proven to be a more difficult endeavor. By its very nature, golf lacks the fast-paced drama of a late-inning home run or a last-second touchdown. Its solitary format means there

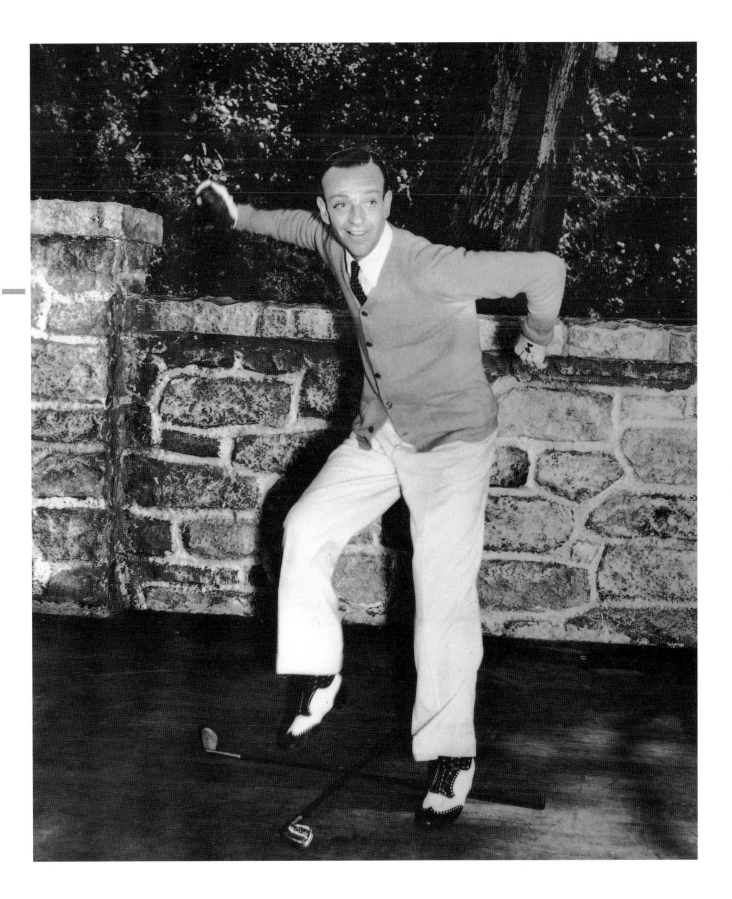

Fred Astaire works on his golf number for the 1938 RKO movie musical Carefree. *The film was the last RKO pairing of Astaire and Ginger Rogers.*

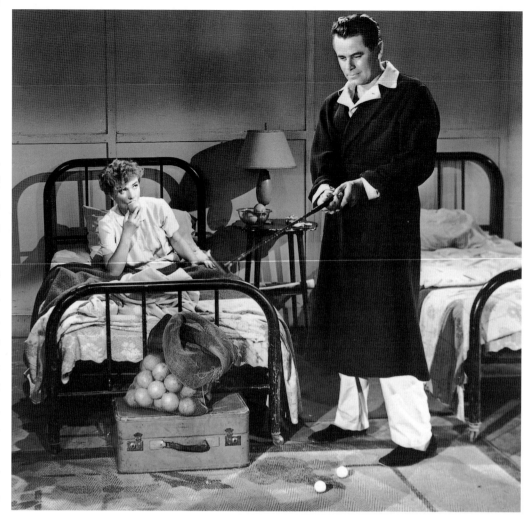

won't be the inter-personal conflicts that team sports afford. So as a cinematic subject, golf remained primarily comedic material until the 1950s when the first serious portrayal was attempted in 20th Century-Fox's *Follow The Sun*. The 1951 film, starring Glenn Ford, told the true story of golf-great Ben Hogan's return to form after a near-fatal car accident. Shot at Riviera Country Club, several pro golfers played themselves in the film and co-star Dennis O'Keefe used his own golf swing. Unfortunately, Ford was not proficient at the sport, so his poor swing was all too evident to golf enthusiasts. Although the serious side of golf was short-lived in the movies, *Follow The Sun* was similar to sports bio-pics of the day such as baseball's *The Stratton Story* (1949) with Jimmy Stewart and the football film *Jim Thorpe, All-American* (1951) with Burt Lancaster. The film had its following, but was never a hit.

In 1952, MGM released the romantic comedy *Pat and Mike*, starring Katharine Hepburn and Spencer Tracy. Hepburn was an accomplished golfer and performed all her own golf shots for the film. The golf course and clubhouse footage were shot at Riviera. "Pro to the Stars" Joe Novak coached Hepburn prior to the film. In the movie, Hepburn was paired with several female professional golfers to add authenticity.

In 1953, Paramount followed suit with the Dean Martin and Jerry Lewis golf comedy *The Caddy*. The golf scenes were also shot at Riviera and featured cameos by some professional golfers, as well as Hope and Crosby. While the comedy didn't break records at the box-office, its theme song "That's Amore" became Martin's theme, plus it won an Academy Award nomination for Best Song.

During the 1960s, golf lent itself to the B-movie market with a few forgettable dramas. Universal released *Banning* in 1967 with Robert Wagner as a tarnished golf pro at a Los Angeles country club. In 1969, Warner Brothers released a bizarre remake of Alfred Hitchcock's *Strangers on a Train* (1951) called *Once You Kiss a Stranger*. The film transferred Raymond Chandler's original story setting from the tennis court to the golf course. Neither golf film did well at the box-office or with critics.

The sixties also saw several films with memorable scenes on the links. Bob Hope's *Call Me Bwana* featured Arnold Palmer popping into Hope's tent in the jungle looking for his lost ball. *Goldfinger*, the 1964 James Bond classic, showcased Bel-Air member Sean Connery's golf talents when 007 matched wits with archenemy Goldfinger on a course in England.

In 1978, National Lampoon's *Animal House* testified to the golf "skills" of Delta House members Boone and Otter, played by Peter Riegert and Tim Matheson. The pranksters aimed golf balls

Glenn Ford starred as pro Ben Hogan in 20th Century-Fox's 1951 release Follow The Sun. *Anne Baxter played his wife, while PGA professionals Sam Snead and Dr. Cary Middlecoff portrayed themselves.*

at their nemesis, Neidermayer, and his horse. A well-placed shot sent both horse and rider galloping off in a panic.

Two years later, Warner Brothers released *Caddyshack*, thought by many to be the best golf movie ever made. A comedy that harkens back to the classic comedies of old, *Caddyshack* featured an ensemble cast of Bill Murray, Chevy Chase, Rodney Dangerfield and Ted Knight. The mayhem at the fictitious Bushwood Country Club makes for hilarious hijinks. The film garnered critical praise and proved its popularity at the box office.

Hollywood's most recent golf movie was Warner Brothers' 1996 release *Tin Cup*, starring Kevin Costner, Don Johnson and Rene Russo. Although not slapstick, *Tin Cup* was still a lighthearted romantic comedy that revolved around golf.

Golf's enduring legacy to film will always be the comedy. From the brilliant silent shorts of the 1920s to W.C. Fields and the Three Stooges in the 1930s, to the 1950s with Martin and Lewis, to the 1980s classic *Caddyshack*, golf and humor were a strong match.

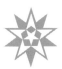

Dean Martin gets the ladies while Jerry Lewis carries the bags in the 1953 Paramount film The Caddy, *which also featured Donna Reed, far left, Barbara Bates and pro golfers Ben Hogan, Byron Nelson and Julius Boros.*

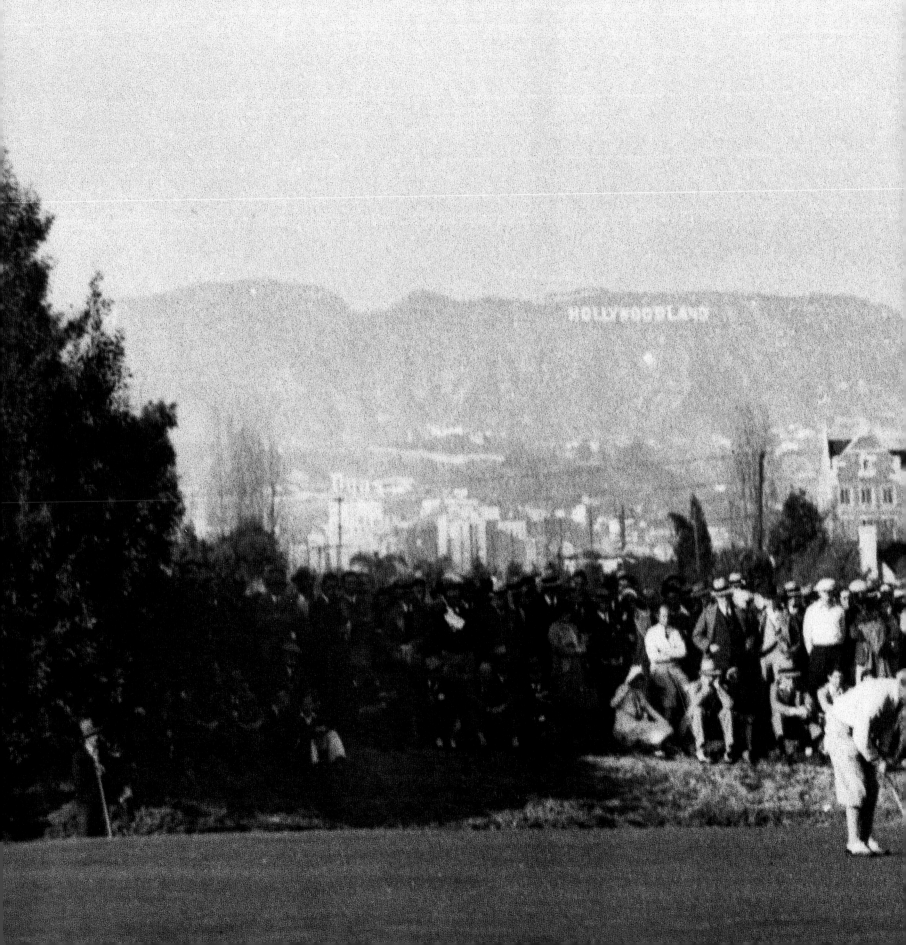

Part II

Where the Stars Come Out to Play

Chapter Three

Los Angeles Country Club

In 1897, Los Angeles appeared to be a water-poor town of eighty-five-thousand residents, not a city on the brink of bursting with wealth in real estate, oil and banking. The motion picture industry was still in its infancy on the east coast. Primitive moving picture exhibitions were held in public viewing parlors in the big cities in the east and in storefronts in downtown Los Angeles. In the late 1890s, enterprising young photographers had yet to think of moving their operations from the cramped lofts of lower Manhattan and Astoria to the warm environs of southern California.

The east coast was also the proving ground for that curious Scottish game of golf, which was beginning to gain popularity in the wealthy suburbs of New York, Rhode Island and Boston. The first golf club in the United States, St. Andrews Golf Club, was founded in 1888 in a cow pasture in Yonkers, New York. But in Los Angeles, there was still not a single golf course to be found. With over three hundred sunny, dry days a year, the climate was ideal for the sport. One downtown sporting goods merchant, Edward Tufts, carried the latest in golf hats and shirts, but could not make a sale. He ended up promoting them as bicycling garb.

When the game finally made its way west, it was initiated on a sandy polo field in Santa Monica in the summer of 1897. Two visiting Englishmen, brothers Walter and Harry Grindley, who often played on the Old Course at St. Andrews, Scotland, the birthplace of golf, casually pushed six tin cans into the polo field at Seventh Street and Nevada (now Wilshire Boulevard), and the first golf game in southern California was played.

The Grindleys and Tufts eventually found a plot of land at Pico and Alvarado Streets, not far from the wealthy neighborhood known as West Adams, and established a course. It was dubbed the "Windmill Links" because of the rough-hewn wooden windmill abandoned on the site.

The first nine holes of their new Los Angeles Golf Club were designed and laid out within a few hours and totaled two thousand yards, with a par of 40. The old windmill was used as the clubhouse, the first in Los Angeles. It took a few days to scrape the clover, ragweed and creosote bush off the flat ground to create fairways. The greens were made of oiled sand called "skins." Again, tin cans were used for holes and local merchants put up signboard advertisements at the hard-pack teeing areas.

Even the founders agreed it was a pathetic example of golf course design and maintenance, but in this case it was all for camaraderie and a good time. Despite its dismal shape, it was the best, and only, test of golf in the city. A few weeks later, an invitation went out to twenty-nine potential charter members. One prospect was Joseph Sartori, a diminutive, mustachioed man and founder of the Los Angeles Security Savings Bank. Sartori would guide the club — and the sport of golf in southern California — into the next century.

On Saturdays and Sundays crowds of Los Angelenos took electric trolleys or rode their bicycles to the city's first golf matches. They laughed at grown men dressed in formal red jackets as they played the "funny Scottish game" on hard-packed adobe.

The very private Los Angeles Country Club's two courses take up close to four hundred acres of prime Beverly Hills real estate with the skyscrapers of Century City serving as the club's southern boundary. The famous North Course, foreground, is considered one of the toughest layouts in the country.

Photo on page 66: The legendary Hollywoodland sign crowns the hills overlooking Wilshire Country Club in its earliest days.

The first golfing exhibitions attracted a hundred new members, with women paying two and one half dollars to join while men were charged five dollars.

The club's success forced the founders to create a committee to handle club affairs. Mark Severance, a real-estate mogul and novelist, was named president; Harry Grindley officiated the matches and was paid five dollars a day. Sartori was made official club handicapper and eventually replaced Severance.

The next year, 1898, was a boom year for the game in the United States. Some four hundred new courses were built. The residents of Los Angeles looked on with enthusiasm, too. Mining millionaire Griffith J. Griffith donated three thousand acres of land near, hoping the city might sport a course on his old property (now called Griffith Park).

The growing golf rage quickly forced L.A. Golf Club founders to expand its facilities to accommodate both its golf and social activities. They settled on forty acres of unused home lots at the corner of Pico Boulevard and 16th Street, near Rosedale Cemetery Convent. In 1898, the club moved to what became known as "The Convent Course" or "The 16th Street Links."

Grindley, Tufts and Sartori created a new, rolling two-thousand-yard, nine-hole layout on the site. The club incorporated officially in 1898 with the new name Los Angeles Country Club and members raised six hundred dollars to build a wood-framed bungalow clubhouse.

Around this time, hotels began to enter the golf world in a major way, too. The Westminster Hotel took over the site of the old Windmill Links and used it as a draw for guests. The Hotel Green in Pasadena created a special course around its landscaped gardens. The Hotel del Coronado in San Diego had the only course in southern California with grass greens. Later on, the Ambas-

The city's first golfers played here at Los Angeles Golf Club's Pico and Alvarado course near today's downtown. Hard-packed adobe made up the fairways and tin cans stuck in oiled sand greens were used for holes. A wooden windmill, partially seen at rear, was the first clubhouse.

sador Hotel built its own links on Pico Boulevard — the Rancho Club (which became the popular public course, Rancho Park).

In 1899, Sartori watched as Los Angeles began growing up around his club. He wanted a full 18-hole golf course, with room to spare. He spied some property, a desolate stretch of grazing land, some hundred-eight acres in total, a quarter-mile east on Pico Boulevard near Western Avenue. It was managed by a lawyer named Henry O'Melveny, who happened to be a member.

The club bought the land for two hundred fifty dollars an acre. Once again, Tufts, Grindley and Sartori set about building a golf course over rolling hills and around a deep *barranca*. The course, known as the "Pico and Western Course," totaled more than fifty-five hundred yards. Par was placed at 80. It was the first 18-hole course west of Chicago.

The price for creating this ultimate golf fantasy had gone up accordingly. Land alone cost twenty-six thousand dollars and another fifteen thousand dollars went to course construction and clubhouse improvements (the old clubhouse from Rosedale had been moved to the new site intact). Later, members raised money to build a grander clubhouse, replete with smoking lounges, bars, billiard rooms and balconies looking out to the Cahuenga Hills (now Hollywood Hills).

As the century ended, the city's first golf club had four hundred thirty members. Nearby, some enterprising real-estate men had the novel idea of promoting lots with views of the course. Their project, called Country Club Park, was a harbinger of major golf real-estate projects of the future, including Bel-Air Country Club and Estates and Riviera Country Club, which were built twenty-five years later. The old Convent Course was taken over by a new group of golfers and renamed Westmoreland Golf Club, which was later sold to real-estate developers.

It took a few years at L.A.C.C. before rounds in the 70s were seen. For the first year, the course record was 88. In 1901, a new record of 79 was set, only to be bested a few months later by a 74. It was no surprise. Newspaper accounts told of the growing popularity of golf in America. New modern implements were being introduced to the game. Scores at clubs everywhere were falling because of the introduction of new rubber-core balls and better iron mashies, niblicks and stronger, more flexible hickory shafts.

But Sartori was still not satisfied with L.A.C.C.'s position in a rapidly expanding metropolis. He and Tufts dreamed of a large clubhouse and two championship courses, with room to expand. Sartori began a search for a site large enough to accommodate the club's future growth.

Throughout 1904, the two men took weekly field trips to the far western reaches of the city. One day, Sartori was brought to a barren tract of land near Morocco Junction (currently Wilshire and Santa Monica Boulevards). There were more than forty-four hundred acres available on a plot called Wolfskill Ranch.

The owner was a wealthy Orange County fruit grower who paid ten dollars an acre in 1880. He tried, unsuccessfully, to raise lima beans and barley on the old ranchland. Sartori liked what he saw. He tried to convince bankers this was the site for his dream. But another group of land developers, with inside knowledge of a plan to run a new railroad line between downtown Los Angeles and Santa Monica, offered one hundred dollars an acre — almost half a millon dollars — for the entire tract. It was a staggering sum, especially for such poor cropland.

Sartori wanted to counter with a hundred-fifty-dollar-per-acre bid, but his investors scoffed, especially for land not even fit to grow lima beans. It was Sartori's folly, they claimed. Nearby, another troubled lima bean ranch, called *El Rancho de Rodeo de las Aguas*, was sold to a land company run by Burton Green, who hailed from Beverly Farms, Massachusetts. He called his new real-estate venture Beverly Hills. Its first honorary mayor was syndicated columnist Will Rogers.

Undeterred, Sartori created a real-estate investment company to purchase land near the new area of Beverly Hills. The company bought thousands of acres and sold some key parcels to members of Los Angeles Country Club. The club ended up with three hundred twenty acres at a price just under fifty thousand dollars for what was to become the "Beverly Links."

The site remained virtually untouched and barren. In 1905, western Los Angeles was a treeless farmland with views of the Pacific Ocean and Catalina Island. With oil fever hitting much of the city, the club hired a drilling company to bore a few test holes on its proposed golf course, but nothing was found.

Two years later, Sartori and his committee, including newly immigrated Scotsman Norman Macbeth, walked the property and began building a new links for Los Angeles Country Club. Macbeth, a top player of the day, roughed out a sixty-four hundred-yard course that straddled *barrancas* and a newly named thoroughfare, Wilshire Boulevard. Sartori picked a hilltop site for the clubhouse. Sartori wanted a long and difficult course like championship courses of the east coast, one fit for championship play. After his work at L.A.C.C., Macbeth landed several key golf design projects, including Annandale Golf Club in Pasadena and Wilshire Country Club.

The Beverly Links course was built for fifteen thousand dollars. The clubhouse and other facilities added another $120,000. The first tee boxes were asphalt. Greens were skins of oiled sand costing fifty dollars each to build. The club experimented with Bermuda-grass fairways, hoping they would survive the dry months of spring, summer and fall. Sprinklers, a first in southern California for a golf course, were added on each fairway. As a result, the Bermuda thrived and, within two years, the entire course was covered with a velvet-like layer of grass. It was not until 1919 that grass greens and tees were added. The new course, with a sprawling clubhouse designed by club member and renowned architect Sumner Hunt, officially opened in 1911.

L.A.C.C.'s grand clubhouse was built in 1911 for less than a hundred twenty thousand dollars. When it opened, Wilshire Boulevard was a dirt road and members were carted up to the club's entrance by carriage from the new train station in Beverly Hills, a mile away.

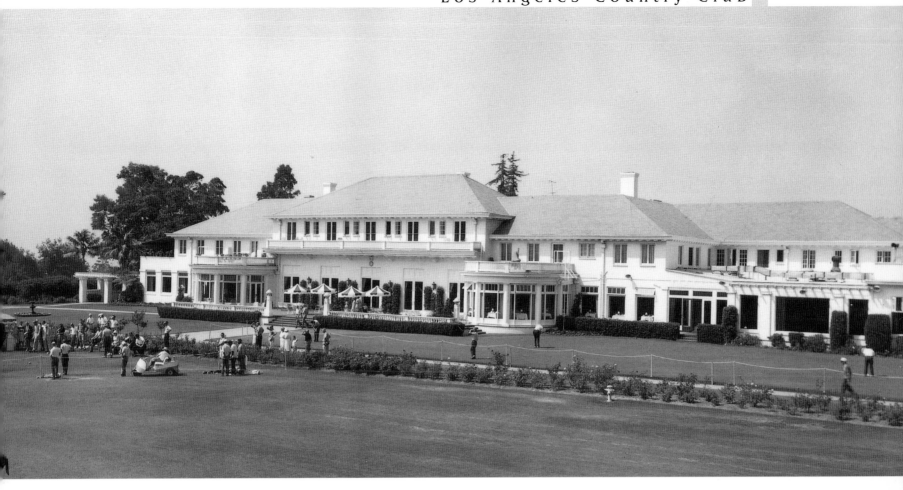

Beverly Hills was ten miles west of where most L.A.C.C. members lived. In fact, the movement of members from Pico and Western to the new development of Beverly Hills helped begin the general migration of city dwellers to the countryside of western Los Angeles. New trolley lines were laid down and new stations were opened along Pico and Santa Monica Boulevards.

Sartori told his club's membership that despite the high cost of Beverly Links, the old Pico and Western Links was worth roughly ten times what the club paid for it. Its sale would relieve whatever debt the new course incurred. In 1920, the club increased its membership to nine hundred and raised funds to buy an additional hundred seventy-five acres north and south of Wilshire Boulevard for the two courses the club has today. An acre in 1920 sold for $1,350, a far cry from the $156 members paid fifteen years earlier. To help finance it all, new members were brought in at the rate of a thousand dollars each and mortgages were secured. A proper golf course design team was hired, includ-

ing G. Herbert Fowler, George C. Thomas, Jr., and his right-hand man and chief earth mover, Billy Bell.

The difficult Depression years of the 1930s went virtually unnoticed at the club under the taut financial reign of Sartori. As president of the club, Sartori ruled over it even more sternly than he did his bank. The club was debt free, owned its property outright and had a surplus of cash. Sartori, who passed away in 1946 at the age of eighty-seven, outlived most original members. The club honors his accomplishments with its annual Sartori Invitational Tournament.

Ed Tufts, from his humble beginnings on a Santa Monica polo field, became known as the "father of golf in southern California." He was revered for his work with the Southern California Golf Association (SCGA), of which he was president for sixteen years. One of his lasting contributions to the game was his tireless organization of inter-club play and, later, his work as president of the California Golf Association. Tufts died of a stroke at age sixty-

Blueprint for a Legend: The North Course

G. Herbert Fowler was California's first professional golf-course architect. Fowler, plotting the North Course here, made clay models of each hole for construction crews to ensure that the details of his designs were carried out.

In 1919, when Joseph Sartori was rethinking the original Norman Macbeth course design for the Beverly Links, he concluded that the best man for the job was G. Herbert Fowler. He admired Fowler's well-known scientific approach. Sartori let the quiet Scotsman make notes, walk the course, shift holes, abandon greens and create new holes at will.

Fowler was the first professional golf course architect to open shop in southern California and was the first designer to use the "target golf" concept popular today among many golf course designers.

Fowler looked over the treeless, parched property and deemed the club's existing track a good skeleton. However, there were a few problems that needed rectifying. He was horrified by the prospect of golfers crossing busy Wilshire Boulevard to play the course. Eventually, a tunnel went under the loud and congested thoroughfare.

The North Course was to have seven featured holes, an extraordinarily large number compared to other courses he designed. As an example, the original first hole for the North Course was changed to become the first hole for the South Course. And, the 15th hole of the North Course was to become the new first hole of the North Course.

This wholesale rearranging and changing went on for a year as Fowler created his masterpiece in Beverly Hills. His "signature holes," the architect predicted, would be three in a row: the uphill 3rd hole (par 4), the long downhill 4th (par 3), and the 5th, an extraordinarily long (440 yards) par 4 that turned to the right. He predicted the very short (135-yard) 15th hole, would be the best short hole in all of golf. Although a tricky hole with a large mound in the middle of the green, it doesn't live up to its original billing.

Fowler traveled extensively. While he was away, the architect sent his notes and clay models to George C. Thomas, Jr., a world-class golf course designer, who was helping Sartori oversee the many projects around the club's two courses. Some claim the designs are by Thomas. Thomas, however, makes it clear in his writings that he "was just carrying out orders from Fowler."

one while playing the club's North Course. After his death, his body laid in state in the clubhouse with his clubs and bag beside his coffin. One thousand mourners paid last respects to the man who had made golf a fixture in Los Angeles.

In the early 1920s, Fox Studios' back lot covered the area now known as Century City. The northern edge of the lot bumped up against Los Angeles Country Club's South Course, where a stand of twisting and turning sycamores stretched. The old, angular trees (some still visible today along Santa Monica Boulevard) were used as Sherwood Forest in the studio's movie, *The Adventures of Robin Hood*, starring Errol Flynn.

Despite its brush with Hollywood movie making, Los Angeles Country Club refused to let stars into its club. Known as the city's "old-money" club, L.A.C.C. still prefers not to entertain the "Hollywood crowd" (former president Ronald Reagan is a notable exception). Early on, actor Randolph Scott tried to become a member at the venerable old-money club. Scott was despondent when he told his friend, entertainer Phil Harris, about his troubles with the membership committee and their dislike with his acting profession.

Harris suggested another approach. "You're no actor, just look at your movies," he said. "You're an oil man." The angle worked, and Scott was allowed membership under the guise of his oil investments. Actor Victor Mature tried this same gambit a few years later, saying: "I've got fifty-six films to prove I'm no actor." But he had no oil wells. He was refused.

From the beginning, its membership has been a Who's Who of Los Angeles businessmen. The city's most prominent bankers, oil barons, real-estate tycoons, lawyers, judges, accountants and publishers have played on the links of L.A.C.C.

The club members' names have always been big enough to draw attention in their own right. In the early years, there were the real-estate-rich Wilshires of Wilshire Boulevard fame, and King Gillette of the razor blade empire. The club's membership has

included such notables as hotel magnate Conrad Hilton, John Paul Getty, Howard Hughes, Sr., and his famous son, the aviation pioneer and Hollywood movie mogul, Howard Hughes, Jr.

Since its earliest days, L.A.C.C. has been quiet about its place in Los Angeles' golf history. The club avoids the spotlight, afraid the glare might shine too brightly on its closed, restrictive membership policies. Its location, championship-caliber North Course, superb practice facility and large and well-appointed clubhouse remain the envy of many clubs throughout the world

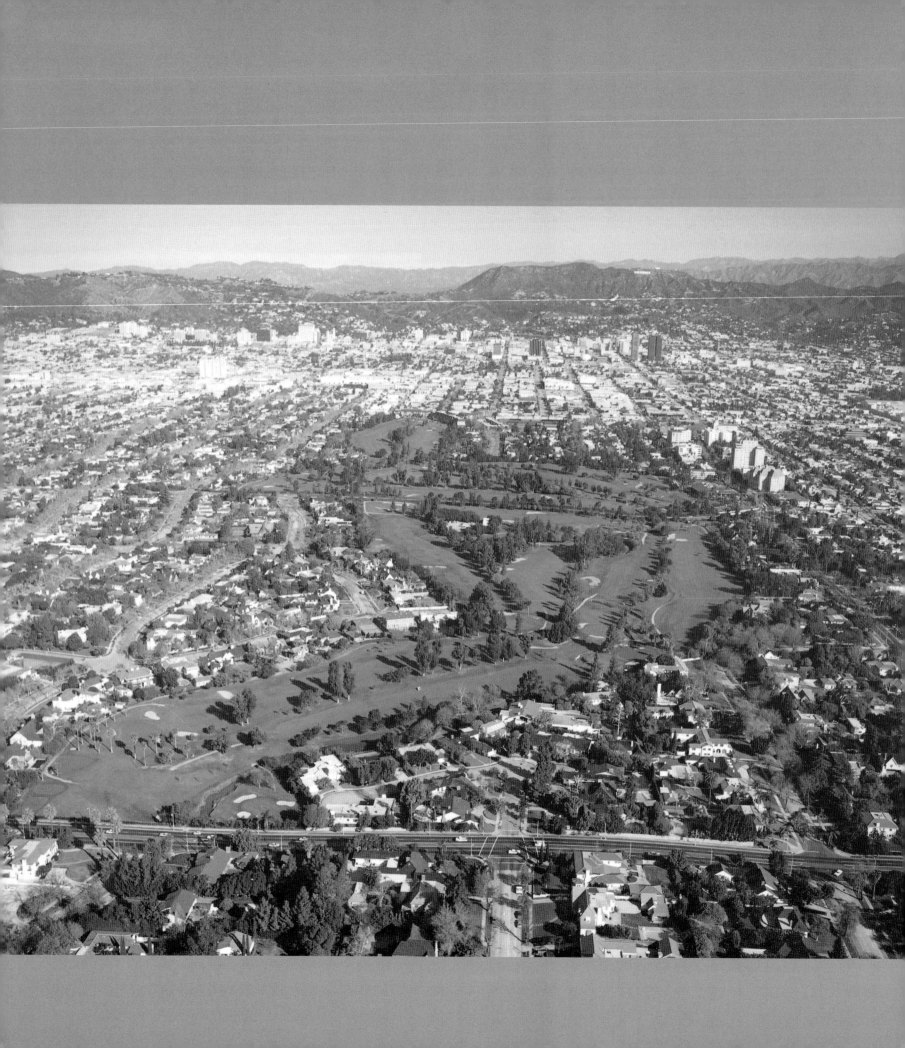

Chapter Four
Wilshire Country Club

Wilshire Country Club is the golf club closest to the heart of Hollywood. It is five minutes from Paramount studios. Charlie Chaplin's old studio is a few miles away on La Brea. Raleigh Studios and numerous television and-film editing houses have taken over the flatlands along Melrose Avenue where the old Sennett and Roach studios used to reside. Yet, like Los Angeles Country Club, Wilshire also shuns the entertainment crowd. It, too, prefers to draw its members from downtown banking, insurance, real-estate and law concerns.

Although not a member, Bing Crosby was sly enough to work his way onto the driving range and course as a frequent guest. He found it convenient to practice there on his way to work at Para-

A former lima bean and oil field, Wilshire Country Club now sits near fashionable Hancock Park on the outskirts of Hollywood. The well-known Hollywood sign looms in the distance and can be seen from most of the course. The Paramount studios can be seen at the far right corner.

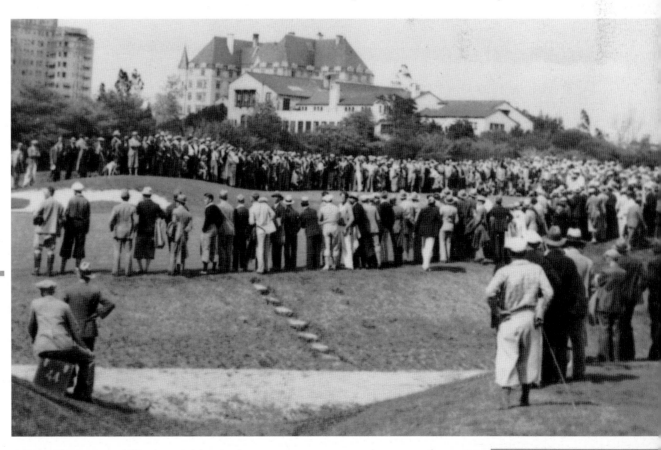

A crowd gathers around the 4th hole to watch Craig Wood tee off the green during the 1933 Los Angeles Open. At left, behind the old clubhouse, stands the El Royale apartment house, home to early Hollywood stars such as Mae West and George Raft.

mount. Both Crosby and Bob Hope tried to become members at Wilshire, but were rejected early. Over the years, the rules loosened a bit and Hope was allowed to join, as were Harold Lloyd, Hal Roach, director George Marshall and song-and-dance man Donald O'Connor.

Founded in 1919, Wilshire is one of the older clubs in Los Angeles. The genesis of the course and the surrounding estates area known as Hancock Park, occurred in 1858. That same year, Major Henry Hancock, an Army surveyor and Mexican War veteran, was given the job of surveying the tiny but growing *Pueblo de los Angeles*. However, since the young city could not afford Hancock's fees, he traded his services for land. Later, he and his brother acquired more land at two dollars and fifty cents an acre. Before long, the Hancock brothers possessed four thousand acres of dusty Los Angeles real estate. Their acreage was laced with *barrancas*, sand dunes and creosote bush. It remained undeveloped for years and eventually Henry's son, G. Allan Hancock, inherited the property.

In the best spirit of the rich getting richer, the young Hancock struck oil on the useless cropland. He quickly started the Rancho La Brea Oil Company in the shadow of yet another new real-estate development, Hollywoodland. Hancock's land was wedged between Hollywoodland and a black tar-filled lagoon called La Brea Tar Pits. Unfortunately, most of Allan Hancock's oil was too thick to refine and the land again sat vacant for years.

When several of the local businessmen approached Hancock about building a golf course on the abandoned oil land, the oil man liked the idea and signed over a small tract to the golfers. It was cut with ribbons of dry creek beds and there were natural plateaus

Standing guard over the 18th hole, Wilshire Country Club's old clubhouse was a mix of California Mission and Mediterranean styles similar to the grand clubhouse that would appear later at Riviera Country Club. It was torn down in the late 1960s to make way for a modern structure.

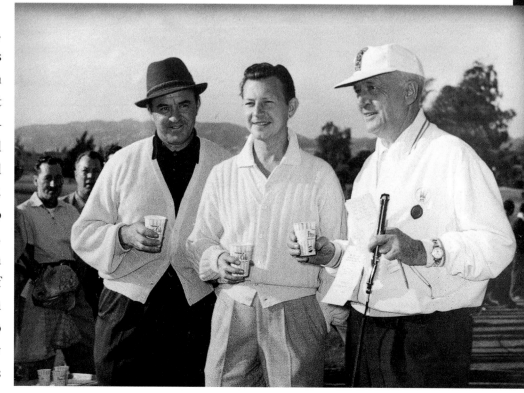

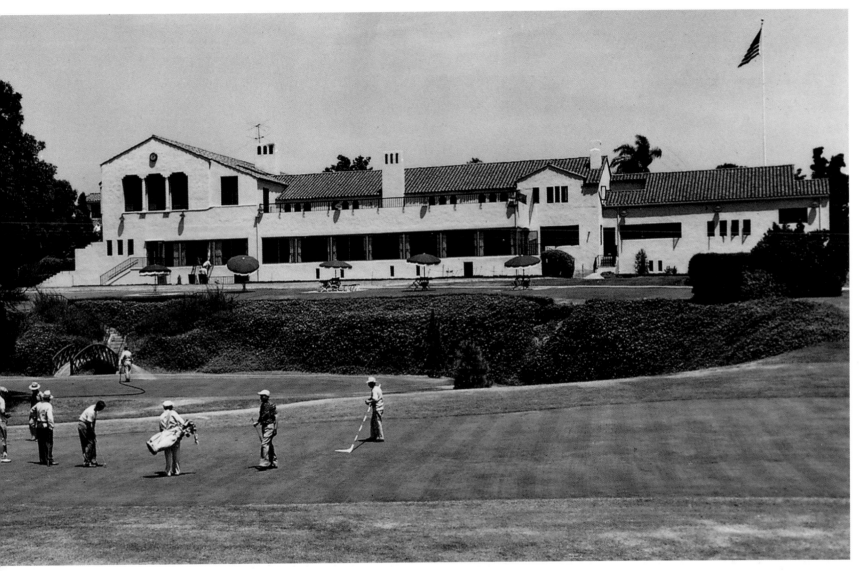

Singing in the Rain's *Donald O'Connor,*
center, one of the few celebrity members
at Wilshire Country Club, stands
between professional golfer Sam Snead,
left, and businessman Carl Anderson
during a pro-am event in the early
1950s.

for greens and broad expanses for fairways. The use of the term "country club" was appropriate since the course was situated well into the countryside of Los Angeles at the time.

A committee was formed to begin the club and included some of the great names in Los Angeles and in golf, including famous tennis pro and Santa Monica real-estate mogul Thomas Bundy, Hancock and grocery store giant E.E. Ralphs. Norman Macbeth, the great Scottish player who helped design the Beverly Links at Los Angeles Country Club, was asked to design the course. It was

Macbeth's Masterpiece

When Norman Macbeth laid out the original Wilshire Country Club course in 1919, it played to 6,321 yards, close to what it plays to today during tournaments (6,531 yards). Today, Wilshire is probably best known for its smooth-as-silk greens. They can be made to speed the ball along as if rolling on marble, yet the ball remains true to its line. Its greatest threats to golfers are the numerous spring-fed meandering creeks and *barrancas* that catch wayward shots.

Wilshire is a course that has stood the test of time. In fact, professionals have had a harder time scoring on Wilshire than at the seemingly more difficult course at Riviera Country Club, site of numerous Los Angeles Opens, the PGA Championship and the U.S. Open. The lowest stroke total made by professionals during the four Los Angeles Open's held at Wilshire was 278 for four rounds, while professionals shattered Riviera with a low total of 264.

Only two holes on the course have seen radical changes. The 1st hole was originally designed to be a monster at 440 yards long, but then there was no Beverly Boulevard cutting through the course. The first tee was where the practice putting green is today. In its present state, with the first tee starting on the other side of Beverly, the hole is a modest 378 yards. The only other hole to see major changes was the 10th. It was close to 200 yards in its original configuration, but some land swapping forced the club to shorten the hole to 135 yards.

Like many great courses, Wilshire's final three holes are memorable. The 16th hole is a par 5 that dares the long ball hitter to fly the hazardous green-fronting creek in two shots. Even professional golfers have to think hard before they make the bold attempt. Most are too fainthearted and opt for an iron shot lay-up. A short wedge shot, if accurate, can provide a birdie putt opportunity on the tilted, lightening fast putting surface.

The 17th hole is an uphill par 4 dogleg left that plays longer than its posted 365 yards. The green is doubled tiered and sits on a knoll that fools players into hitting either too short or too long. Few players make par here if the green is missed.

But the 18th hole is the club's signature hole. A long downhill 440-yard par 4, the 18th cuts back to the clubhouse and players then must circumnavigate the ever-present meandering creek that cuts around and to the side of the green. A good drive can set up a long-iron shot to an "island" green surrounded by the snake-like creek. More often than not, the 18th dashes a good round with a double bogey, or worse. And all that happens in plain view of golfers and spectators sitting on the clubhouse verandah.

Norman Macbeth was asked to design Wilshire's course after his success with Los Angeles Country Club's original North and South courses.

A young Bing Crosby hones his game at Wilshire's driving range. Though not a member, Crosby, the consummate "schmoozer," was able to work his way onto the private course between takes at nearby Paramount Pictures.

a tight, hundred-acre parcel between Melrose Avenue and Third Street. Oil wells dotted the landscape. (Even today, large patches of oozing black tar can be found on the course.)

When Macbeth designed the course, Temple Street ended at the clubhouse and turned south on what today is Rossmore Avenue. In the background, perched high on the Cahuenga Hills, a sign spelling out "Hollywoodland" was erected to promote the new real-estate project. The giant billboard was ever-present from the course, as is the "new" Hollywood sign today. In 1925, Temple Street became Beverly Boulevard and cut directly through the course, bisecting it into two nine-hole tracks connected by a tunnel under the road.

Before long Macbeth transformed the former oil field into fairways and greens. By 1920, Wilshire Country Club was open for play. Wilshire's old clubhouse was a large, multi-winged classic mix of Mediterranean and California Mission architecture that sat above the course, overlooking the signature "*barranca* holes" of 16, 17 and 18, as well as the 220-yard par-3 10th hole. The grand Mission structure was demolished in the late 1960s and a new two million dollar modern facility was erected in its place. Though not as classic as some may have liked, the new clubhouse offers a commanding view of the best golf links in downtown Hollywood. In tribute to its designer, the club holds the Macbeth Invitational each year.

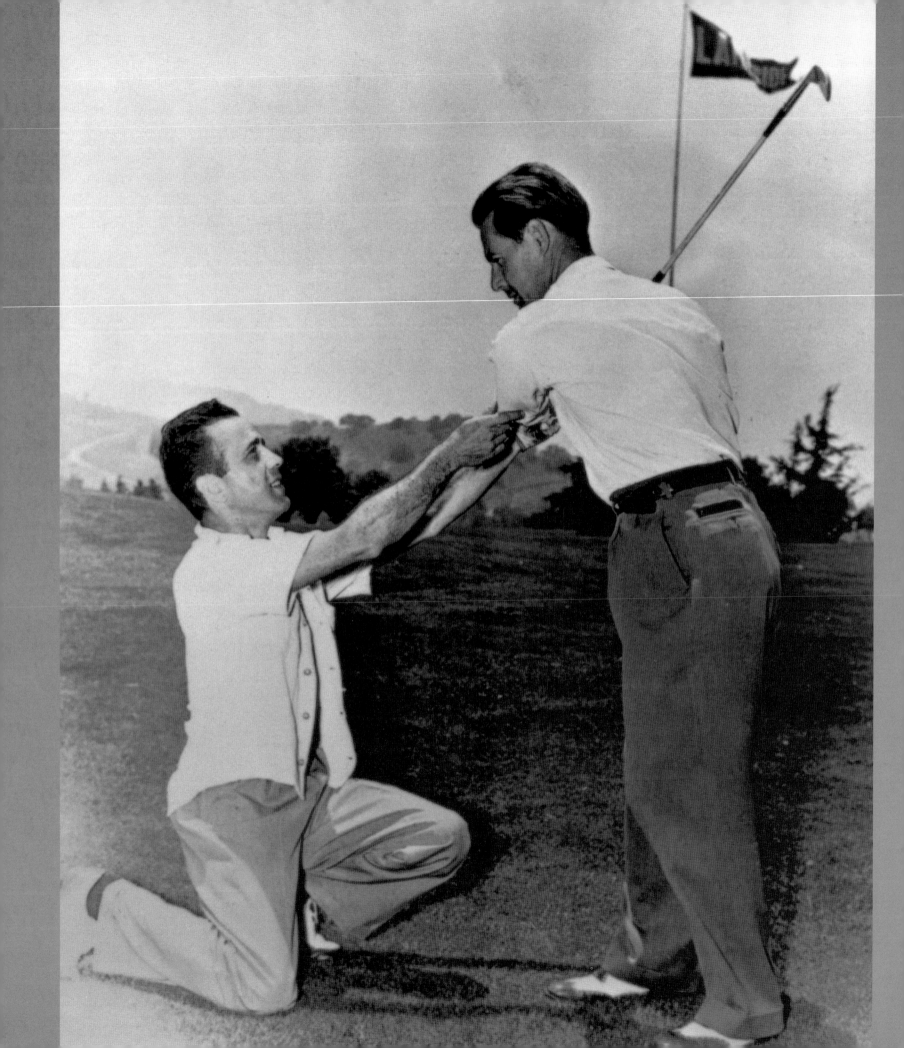

Chapter Five
Lakeside Golf Club

Despite its proximity, the polar opposite of Los Angeles and Wilshire Country Clubs can be found on the other side of the Hollywood Hills. Just a long-iron shot from Warner Brothers and Universal Studios, Lakeside Golf Club in Toluca Lake is the one place in Los Angeles where the game of golf and the stars of Hollywood come together in one glorious cocktail.

More than half of the club's members come from "The Industry," that is, the Hollywood movie, television and music world. But Lakeside's position as the heart of Hollywood's golf universe should not disguise the fact it is among the most challenging courses in southern California, with some of the tightest fairways and best greens in the city. And its history is just as good.

The club was founded in 1924 after a meeting of eleven businessmen in the Hollywood Athletic Club on Sunset Boulevard. The men knew other clubs were being built in the far western corners of the city and felt there was a viable opportunity to bring golf to its eastern edges. With the huge economic surge of the Roaring Twenties, even though land prices were climbing Los Angeles saw five new private country clubs under development between 1924 and 1928.

There was stiff competition for members, so the founders opted to develop a club near the growing entertainment business. They deemed that the western environs of Los Angeles were

Film tough guy Humphrey Bogart takes time out to offer a fellow Lakeside member some pointers on the fine art of the golf swing.

too far from the popular Musso & Frank's and Brown Derby eateries where stars dined regularly, and from the parties in the hills and the prevailing, appealing hustle-bustle of Hollywood.

At the time, the best open land available was just over the dirt roads of the Cahuenga Pass, Los Angeles' main link to the orange groves and walnut orchards of the San Fernando Valley. The founding members purchased a patchwork of farms and orchards in the Valley, which surrounded a small, kidney-shaped body of water called Toluca Lake and bordered the dry wash of the Los Angeles River. The lake became the scenic northern edge of the club's property, almost a hundred thirty acres in the end, and the Los Angeles River was the natural southern boundary. Directly across the river was Universal Studios and its zoo, where the studio housed wild animals for jungle movies. The river would prove to be an integral part of the course layout.

After negotiations, cash down payments and a host of promises to the orchard owners, the Lakeside Golf Club of Hollywood was formed on May 12, 1924. One of the founding members, James B. Irsfeld, was elected the club's first president. He stayed in the position until 1936, guiding the club through the rough years of the Depression.

Funds were slated to come from membership sales, but in the first few weeks of drumming up takers, few came forward. Eventually, the fees were lowered from one thousand dollars to seven hundred fifty dollars. Two hundred members signed up, allowing the building to begin. When the fees were again raised to one thousand dollars, membership predictably fell off and funds dried up. So went the first year at Lakeside Golf Club.

One young board member proposed that the club find twenty-five new members who would loan it five thousand dollars apiece for five years at four percent interest, and in return receive lifetime memberships. The idea paid off; implementing the novel approach raised $125,000 for Lakeside within a few days. One investor was Thomas O'Donnell, a member's cousin and resident of Long Beach. O'Donnell later became famous for creating the exquisite nine-hole O'Donnell course in Palm Springs, where celebrities hoping to win a few extra bucks often played.

Max Behr was the membership's choice for designer. Behr, a Scotsman who assisted Norman Macbeth with Wilshire Country Club's layout, was one of the better golfers in the country. He was paid the handsome fee of twenty-five hundred dollars to design the course. Behr used the old walnut and peach orchards to his advantage by creating narrow holes. Because of the numerous trees, there were few visible up-and-back parallel fairways on the course. It was a nice change from the treeless playing grounds of most Los Angeles courses.

When the course first opened on October 11, 1925, it was lauded as a one of the great tests of golf in California. It played longer than it looked due to the loamy, ball-stopping soil under the bluegrass fairways. The soft fairways were in contrast to the usually concrete hard links Los Angeles golfers were accustomed to playing on. The greens were built large and undulating, to be played with much trepidation. Grass greens were still something of an experiment even in the 1920s in southern California. A new variety of creeping Cocoos Bent grass was planted, resulting in the fastest greens in the city.

When the club opened, five hundred spectators showed up to watch two top amateurs, Norman Macbeth, formerly of L.A.C.C. and recently of Wilshire Country Club, and George Von Elm of Rancho Golf Club, who ranked as one of the world's greats, play against professionals "Wee" Willie Hunter of Brentwood Country Club and Jack "Texas Wildcat" Tennant of El Caballero Country Club in the San Fernando Valley.

The crowds loved the match, which was interrupted often with wild roars from lions and other animals at the adjacent Universal Zoo. The amateurs went two up after nine holes, but ultimately fell to the pros one down on the last hole.

From its earliest days, Lakeside looked for members who would add star quality and Hollywood money to its roster. It was a natural idea to embrace Hollywood royalty. With America's insatiable appetite for comedies, three-reel dramas and western action pictures, the silent-movie industry was booming.

In 1925, Universal Studios and Paramount's back lot "ranch" (now Forest Lawn Cemetery) were the only studios near the club. But that changed in 1926, when First National Studios built its new facility across the street from Lakeside on Barham Road. First National was soon taken over by Warner Brothers, where many Lakeside members worked behind or in front of the cameras.

Many of the big Hollywood names — such as Fairbanks, Fields, Hope and Crosby — joined multiple clubs both as a status symbol and for the option to play several top courses regularly. It also provided insurance. In the event that some of their shenanigans got them expelled from one club, they always had another place to play. Nevertheless, Lakeside retained its crown as king of the celebrity golf clubs.

"This is no ordinary country club," Bing Crosby said of Lakeside, where he and Bob Hope played and partied thousands of times. "Raillery, gags, ribs, frame-ups, put-ons and put-downs are incessant, and often hilarious — and no one is immune."

The first well-known celebrity to join the golf club was baby-faced vaudeville comic Harry Langdon. Asked what he thought about joining Lakeside, he replied: "I would be very proud to join the only club in the world with 1,018 holes." When pressed by the club's president as to what he meant, Langdon replied: "Yes, eighteen holes for golfers and a thousand for the gophers." Fortunately, Lakeside has since solved its gopher problems.

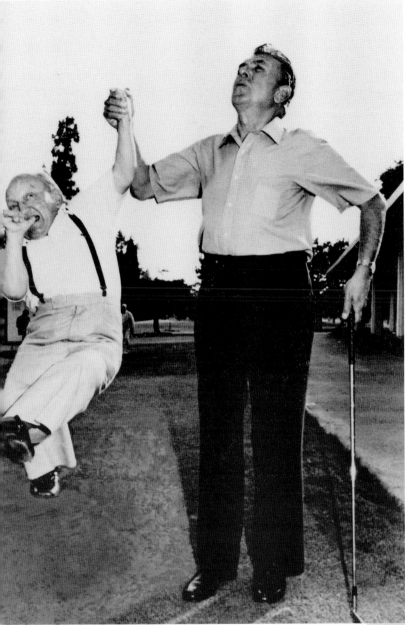

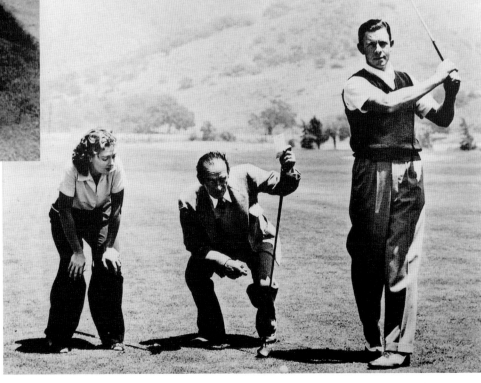

Forrest Tucker holds fellow actor Billy Barty in a classic take-off on the photo of W.C. Fields holding his sidekick, child actor Baby Leroy.

Ruby Keeler and Andy Clyde keep their eyes on the ball as George Murphy swings — and misses. Keeler was on the Lakeside Women's Golf Team and was one of Hollywood's best female golfers.

85

The first wave of Hollywood movie stars to sign on at Lakeside started with the silent-era actors such as C.J. "Slim" Somerville, a comedian famous for his role in the serious movie *All Quiet On The Western Front*. Mary Pickford and husband Douglas Fairbanks started playing the game at Lakeside. Always the great athlete, actor and stuntman, Fairbanks shot an incredible 86 the first time he played on the new links. But, as it often happens with the finicky game, he was not able to break 100 for another six months, even with the help of the club's professionals, Charlie Guest and Willie Low.

Other early Hollywood luminaries included John Barrymore (a weak golfer though expert drinker), Walter Huston (a decent player), radio comics Bert Wheeler and Robert Woolsey, directors Howard Hawks, James Tinley, Henry King, Lloyd Bacon, Raoul Walsh, Gregory LaCava, John Ford and Edward Sutherland. During the 1930s and 1940s, the club roster read like a William Morris Agency directory, with tough guy Milton Sills, William Frawley, Harold Lloyd, Gene Autry, Basil Rathbone, Randolph Scott and Johnny Weissmuller all signed on.

Membership was a virtual *Who's Who* of Hollywood with comedians and dramatic actors alike thick at the Men's Bar. It was common to see Oliver Hardy, Adolphe Menjou, Dick Powell, Errol Flynn, Gary Cooper, Ronald Reagan, Edgar Bergen and Walter Brennan hoisting drinks in the darkened room. Don Ameche, Humphrey Bogart and Mickey Rooney were regulars, too John Wayne was a member, though he never played golf. He enjoyed the champagne, tequila and cards.

Female film siren Anna Q. Nilsson was the first actress admitted to the club. Later, Charlotte Young and Ann Sothern joined, while Jean Harlow and Paulette Goddard also frequented the club. Lakeside also fielded a strong female celebrity golf team, which included Ruby Keeler, Ginger Rogers and Dolores Hope. Though not members, Babe Didrikson and Amelia Earhart often played there. The famed aviatrix lived in a small house next to the club.

A typical day of raillery at Lakeside Golf Club ended in the locker room with Bing Crosby, standing left, and Johnny Weissmuller, seated center, holding court with pals after the first Victory Tournament in 1942. That's club hampion Johnny DePaulo standing in the center.

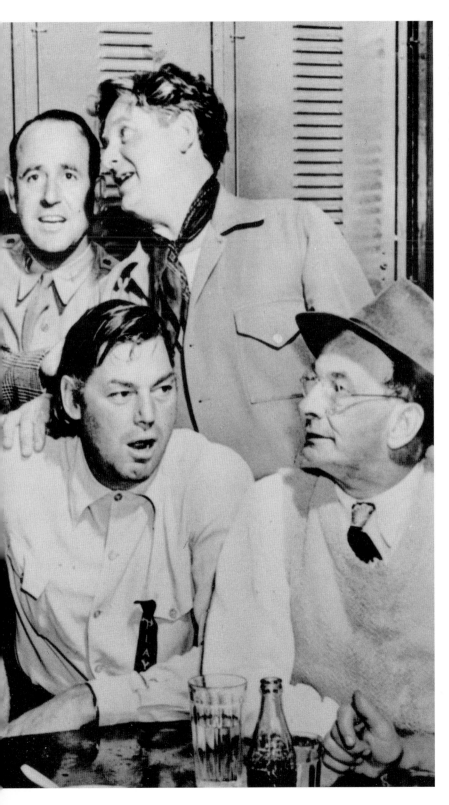

W.C. Fields was among Lakeside's most infamous members, not only for his antics and his sneaky good game, but also for his hilarious golf movie shorts. One of Fields' regular golf partners was Oliver "Babe" Hardy, who, at one point in a round, pulled out a new club, a iron niblick with a heavy flange (the forerunner to today's sand wedge). Fields' rejoinder upon seeing the odd golf club was: "Any man who would use an illegal club like that would strangle his mother."

Bing Crosby happened upon Lakeside in 1929 when he was a singer with Paul Whiteman's orchestra, then recording for the movie *King of Jazz* at Universal Studios. Crosby was an 8 handicapper then, but by the time he joined Lakeside in 1930 his handicap dropped to 2 and he had become a singing sensation with the ladies. In 1936, he won several club championships at Lakeside, an honor still held by only a few entertainers in golfing history. Crosby won four club championships in total at Lakeside, and was the club's first four-time winner.

With the studios so near, and golf taking hold of actors, directors and producers, it was not long before the cameras arrived at Lakeside. In the 1930s, Bobby Jones, winner of golf's Grand Slam (the U.S. Amateur, U.S. Open, British Amateur and British Open), was America's hero. Warner Brothers paid him the sizable sum of two hundred thousand dollars to make a dozen instructional golf shorts directed by George Marshall. Six were filmed at Lakeside, including the mid-iron and putting shorts.

Lakeside was a gossip columnist's dream. There was constant fodder. Mickey Rooney, for instance, known to have the worst temper at Lakeside, was the only actor ever to be thrown out of the club. A darling of the 1930s, along with Judy Garland and Shirley Temple, Rooney would sing, dance, laugh and swear his way around the course. He was a good golfer, claiming a "Hollywood Handicap" of 3 in his prime. His mirth and mercurial ups and downs on the course, however, made members duck for cover when he was looking for a game.

Donna Reed, left, Linda Darnell, center, and Marguerite Chapman were among the famous scorekeepers for Hollywood tournaments. Female celebrity scorekeepers were part of the draw at all of Luxford's tournaments.

"Mister Golf"

Known simply as "Mr. Golf," Maurice G. Luxford invented the business of celebrity golf tournaments. Luxford developed the idea of "Victory Tournaments" during World War II and later chaired the Crosby Pro-Am Invitational, as well as numerous other celebrity charity tournaments.

A native New Zealander and a decorated rugby player, Luxford's goal in offering tournaments was to combine the fun of celebrities playing golf with serious-minded professionals while raising money for the U.S. war effort and generating excitement for the public. He started his efforts with Bing Crosby and Bob Hope promoting war bonds.

The Victory Tournaments were highly touted events in Hollywood, bringing out the media, the stars and the fans. Popular actresses of the day were called on to be scorekeepers or tournament "queens." Some of the more famous "girls of the greens" were actresses Linda Darnell, Paulette Goddard, Donna Reed, Ann Miller and later, even Marilyn Monroe.

After World War II, Luxford organized the Annual Frank Borzage Motion Picture Tournament. Other celebrity-driven tournaments that developed from Luxford's work include the Andy Williams San Diego Open, Danny Thomas St. Jude Memphis Open, Glen Campbell Los Angeles Open, Sammy Davis, Jr., Greater Hartford Open, Frank Sinatra Palm Springs Charity Pro-Am and the Dean Martin Tucson Open.

Luxford's legacy had an effect on women's golf, too. Dinah Shore became well-known for her Nabisco Dinah Shore Classic held every year in Palm Springs. During the 1950s and 1960s there were so many celebrity charity golf tournaments raising money for various hospitals that Jerry Lewis once said: "By the time I arrived in Hollywood, all the diseases were taken."

Fred MacMurray, left, and Desi Arnaz, center, at the Crosby Pro-Am in Pebble Beach getting their "Luxford introduction" by Mr. Golf himself. Luxford was famous for his glowing introductions at celebrity tournaments, making little-known actors and out-of-town businessmen feel like Oscar winners.

Maurie Luxford takes the podium with Clint Eastwood and an unidentified player at a celebrity tournament for March Air Force Base.

Everybody's Favorite Partner

Ralph "Shaggy" Wolf was not an actor, producer or director. He made his money in the tire business. Some called him the world's greatest salesman. However, Wolf became a golf partner and confidant to many of Hollywood's upper-echelon stars, including Bing Crosby, Bob Hope, Dean Martin and Frank Sinatra. Crosby gave him the nickname "Shaggy" one day at Lakeside when Wolf, who owned a tire business, showed up in his dirty overalls. Bing said he looked "awfully shaggy," and the name stuck.

Making the rounds in Hollywood, Shaggy was closer to some stars than their agents were. On one occasion, Shaggy was trying to reach Bob Hope at a hotel in New York and the operator tried to put him through. When Hope wouldn't take the call, Wolf asked the operator what name she used. She replied "Ralph Wolf." He instructed her to "Say it's 'Shaggy' Wolf." Hope took the call immediately and said, "Hey Shaggy, I didn't know your name was Ralph."

In 1937, Wolf won the inaugural Bing Crosby "Clambake" Tournament in Rancho Santa Fe. He and his caddy entered the tournament when a pro failed to show up. They won a small amount of money and the caddy won a new set of clubs. Later, Crosby won the clubs back from the caddy in a match at Lakeside, which infuriated Shaggy. To get even with the famous crooner, Wolf set up Bing with a "nice" set of white wall tires for his car, that Bing willingly accepted. Shaggy took four used ten-cent tires,

polished them like new and put them on Crosby's car. Bing drove off and as soon as he hit the brakes hard, the tires all exploded.

After selling his tire business in 1942 and losing his money gambling, Wolf got into the promotional item business, selling lighters, cuff links and combs to the growing number of hotels and casinos in Las Vegas. Wolf's prowess as a salesman was legendary. While in Las Vegas for a pro-am tournament, Shaggy was in a hotel restaurant with Arnold Palmer and a few others. One fellow at the table was doubting Shaggy's salesmanship.

Palmer vouched for Shaggy saying, "Yep, he's the world's greatest salesman." The doubter said, "Okay, there's Sinatra sitting over there. I'll bet you a thousand dollars that you can't sell him something right now."

Shaggy stood up and in his booming voice said "Hey, Frank!"

"What is it, Shaggy?" Sinatra replied.

"This S.O.B. wants to bet me a thousand dollars that I can't sell you a thousand lighters."

"You tell him he just lost that bet," Sinatra answered.

One day, Dean Martin, his golf pal Art Anderson and Wolf were driving out of Los Angeles to Woodland Hills Country Club. "Why in the hell are we driving all the way out to Woodland Hills to play golf?" Shaggy asked. Neither Martin nor Anderson had the heart to tell Shaggy that he had been banned from every other golf course in Los Angeles.

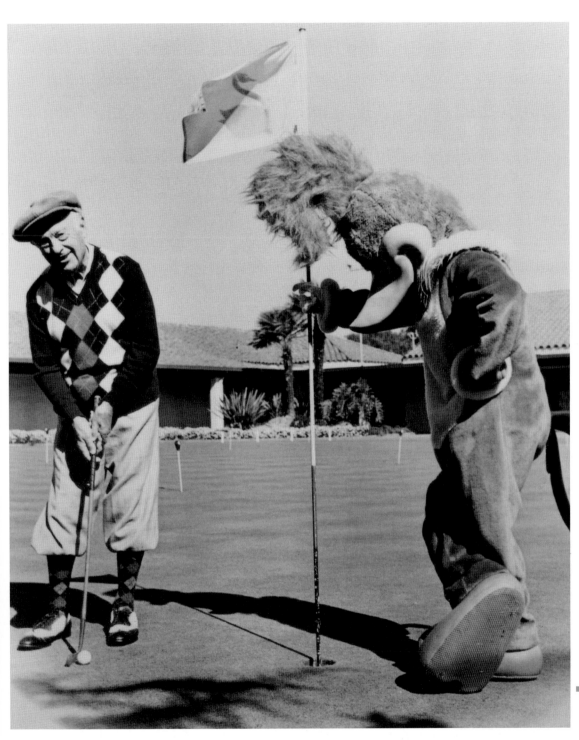

Lakeside's best golfers were not in the entertainment business, however. Some of the best players in the world were members there, including Von Elm, Roger Kelly, Johnny Dawson and Bruce McCormick, all major amateur golf stars in their own right.

During the 1950s and 1960s, the new television stars were in abundance, too, such as Andy Griffith and Don Knotts, Jim Nabors, "Lonesome" George Gobel, Efrem "FBI" Zimbalist, Jr., and Forrest Tucker of *F-Troop* fame.

By the late 1980s, a new generation of celebrity members, such as Jack Nicholson, Joe Pesci, Andy Garcia, rock musician Eddie Van Halen and others were keeping Lakeside's star-studded traditions alive and well. As always, Lakeside remains home to Hollywood's most famous golfers.

Walter Lantz poses with his most famous creation, Woody Woodpecker, on the practice green at Lakeside. Woody Woodpecker came to life in the 1940s at Universal Studios, across the Los Angeles River from Lakeside's back nine.

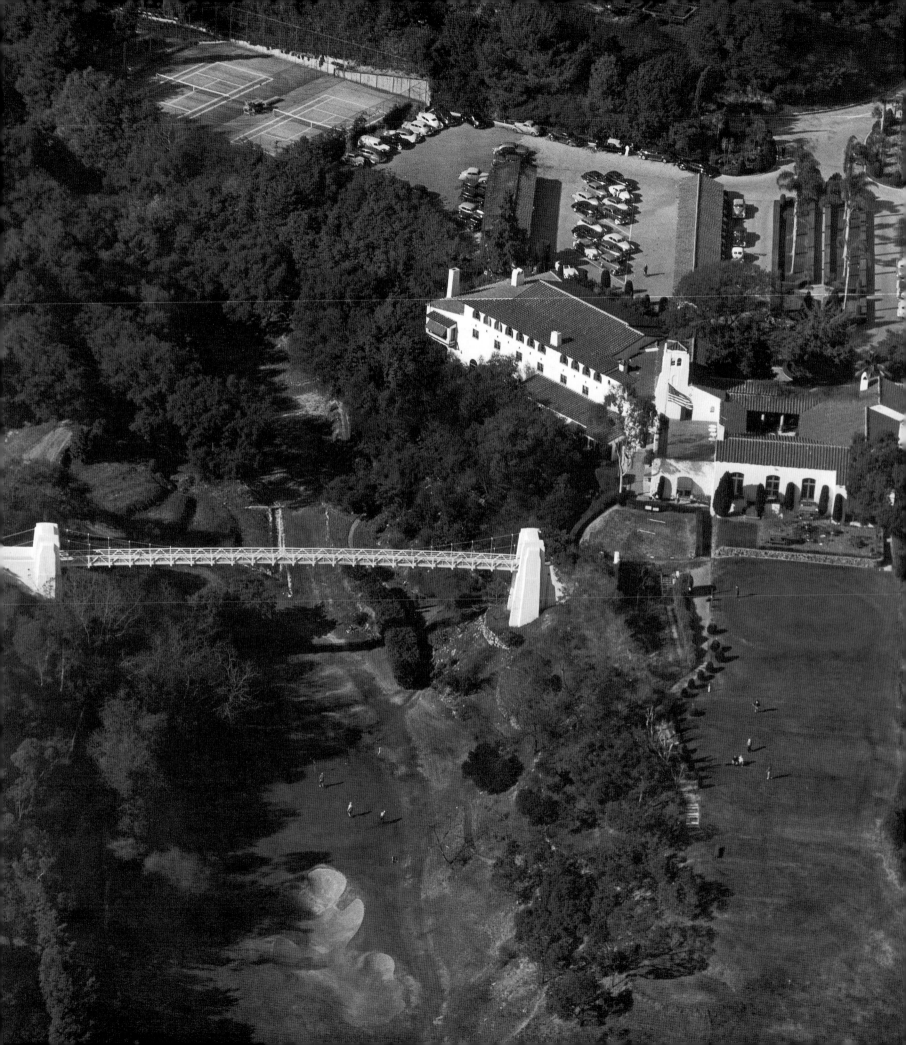

Chapter Six
Bel-Air Country Club

L ike so many great fortunes made in southern California in the early part of the twentieth century, Alphonzo Bell's came when he was least expecting it.

A Bible-toting produce farmer, Bell was running short of water in his wells. His crops were dying. He called in a drilling company to bore a new well. Instead of water he found oil, an enormous tract of it. Overnight, the conservative grower from Santa Fe Springs became one of the wealthiest men in the U.S. Over the next fifteen years, Bell's oil gushed and with it so did his bank account. With his vast profits he acquired large parcels of prime Los Angeles Basin real estate. In 1922, he purchased a 1,760-acre ranch, part of which now makes up Bel-Air Country Club and the surrounding gated estates. He paid more than one million dollars for the property, roughly six hundred dollars per acre, four times what the members of Los Angeles Country Club paid for their nearby land two decades earlier.

Besides collecting land and reading the Bible, Bell was an avid sportsman. He played both golf and tennis and began thinking about building his own golf course, one that would rival the fashionable Beverly Links of Los Angeles Country Club. His first Bel-Air course was to be on the land that is today Wilshire and Sepulveda Boulevards. But Bell changed his mind. He abandoned the Sepulveda site, where the Los Angeles Federal Building now sits, and focused his attention on his holdings just north of Sunset Boulevard then just a dirt road.

Bell traveled extensively in Europe with his family in the early 1920s. Their trips abroad took them through scenic Italian villages, the Island of Capri and the French countryside. To Bell, the rolling green countryside of northern Italy and southern

A view from the sky in the late 1940s shows off Bel-Air Country Club's signature Swinging Bridge and original clubhouse. The bridge spans a one hundred-fifty yard canyon and the 18th green. The practice putting green and first tee are at far right.

93

France reminded him of the rolling hillsides of his newly-acquired property in the Santa Monica Mountains. Once back in California, Bell had visions of a secluded millionaire's village similar to what he had seen in Europe. He believed, however, that a special draw was needed to compete with developments such as Beverly Hills. He made plans for a golf course with surrounding home sites, an idea relatively new to the west.

The 1920s were proving to be an era of luxuries; wallets got fatter and the sounds of jazz bands, flappers and Stutz-Bearcats roared through the decade. Across the United States, dignified golf-course communities were springing up. New courses by such master designers as Donald Ross, Dr. Alister MacKenzie and A.W. Tillinghast were opening monthly as golf's popularity surged.

Bell set aside one hundred thirty-five acres from his original purchase for his golf course. He broke up the surrounding land into one-acre tracts (selling each for a staggering twenty thousand dollars), created winding roadways and finally attached a name to the area: Bel-Air Estates. Bell chose a location on the highest hilltop for his own lavish home, *Capo di Monte*.

In 1924, prior to the start of construction, Bel-Air Country Club offered three hundred memberships for sale, with the first hundred going for one thousand dollars each. The following fifty memberships were sold at fifteen hundred dollars and the next hundred for twenty-five hundred dollars. For the slow movers, the remaining fifty were sold for three thousand, a substantial sum of money. Bell's philosophy was to give men of substance a course they had never seen. To further this idea, he put all the money gained from memberships back into the club and used five hundred thousand dollars of his own funds to design and build Bel-Air.

In 1924, course designer George C. Thomas, Jr., was making a name for himself in golf course architecture. Thomas was instrumental in helping G. Herbert Fowler turn Los Angeles Country Club's North Course into a championship layout. He also

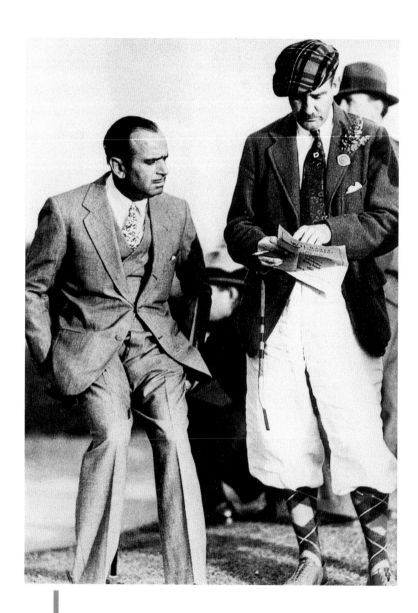

Douglas Fairbanks chats with golf writer Harold Farrington during the filming of a Bobby Jones instructional film at Bel-Air in the early 1930s. Fairbanks participated in one of the golf shorts, as did other Hollywood legends.

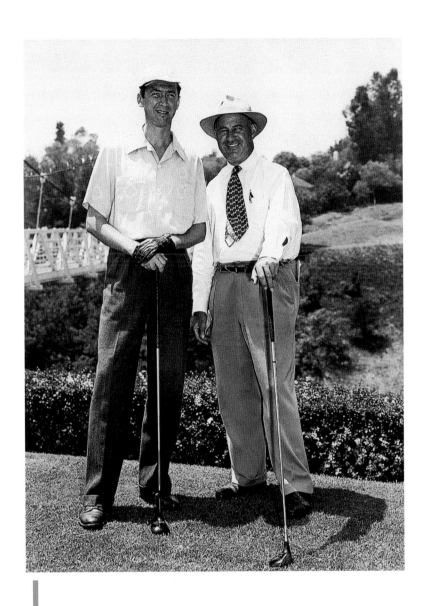

Jimmy Stewart, a longtime Bel-Air member, takes a lesson with Bel-Air's Joe Novak, an early "pro to the stars." Novak's students included Katharine Hepburn, Clark Gable, Randolph Scott and Gary Cooper.

redesigned Los Angeles' Griffith Park courses.

Bell sought out Thomas for help in the early design stages. He also asked Jack Neville, a multiple winner of the California Amateur Golf Championship, for advice. Neville was instrumental in the layout of famous Pebble Beach golf course in Carmel, along with Thomas' right-hand man and long-time "earth mover," Billy Bell.

To gain a better perspective, Thomas, a decorated World War I bomber pilot, took his private plane above Alphonzo Bell's canyons. He tracked the flow of the layout to see how it fell naturally through the private canyons and rolling hills. Much of the course's land ran down the hills and onto the flats over Sunset Boulevard. In the winter of 1924, ground was broken for the Bel-Air Country Club. Horse-drawn equipment did the lion's share of the hauling and scraping, and was manned by Thomas' and Billy Bell's experienced crew of a hundred fifty men. To build Bel-Air, the designers used over twelve hundred tons of local beach sand. By the spring of 1925, the front nine holes were almost complete.

A prize-winning horticulturist in his own right, Thomas learned of Cocoos Bent, the grass variety cultivated in Oregon and tested successfully at Lakeside Country Club. Cocoos Bent drained easily and held up well over long periods of dry weather. Southern California's climate was a perfect match for Cocoos. Bel-Air soon had smooth, fast greens like those at Lakeside.

To map out the back nine holes, Thomas needed some creative inspiration. The initial plans had the remaining holes running south of Sunset, but the land, owned by the Janss Corporation, was unexpectedly bought by the state of California for the new campus of the University of California at Los Angeles.

Thomas, Billy Bell and Neville strolled the grounds looking for ways to carve through the narrow canyons. On the west side of the hill, where the clubhouse was to be built, they stopped at a wide canyon, some one hundred fifty yards across. Thomas suggested that if it could be driven, it opened an entirely new set of holes

The Swinging Bridge

Bel-Air Country Club is considered the "sleeper" golf course in Los Angeles. Its front nine is a gentle lamb, a warm-up that lulls the uninitiated into ideas of greatness. It is the back nine, starting directly with the 10th hole, where Bel-Air becomes a dream killer. Some claim it is as brutal as any nine consecutive holes put together in golf. As the saying goes, if you're losing your match on the front at Bel-Air, don't worry, the game does not start until the 10th hole.

The course has remained basically true to the original 1925 George Thomas design, but there have been some modifications. For example, the 12th hole, known as the "Mae West Hole," has lost the two large mounds that fronted the green. On the front nine, there are notable holes, the best being the 4th, not only because it is difficult but because of its history. On the left side of the hole there is a rock outcropping that rises two hundred feet to a mesa that holds up one of the largest estates in Los Angeles, the former Conrad Hilton mansion. Hidden in the rock outcropping is the cave where Johnny Weissmuller filmed scenes for the original Tarzan movie. When Weissmuller played the course, he would run up the rocky slope and give his jungle roar.

The 4th hole is a long par 4 and stretches along Stone Canyon Drive for 440 yards. Until a storm blew it over in 1992, an ancient, overhanging sycamore tree defined the 4th hole. It jutted out from the right rough like a giant arm waiting to swat down good drives.

The 10th hole at Bel-Air is one of the club's two signature holes. It's known as the "Swinging Bridge" hole, because of the long suspension bridge over a deep canyon between tee and green. The 10th tilts uphill, stretching it out another 20 yards. Most players hit woods or long irons to the green. Only the longest hitters consider using anything less than a long iron. Bel-Air has always been known for its fast greens, but the green at the 10th hole is particularly treacherous if the pin is placed in the front. Landing above the hole, a 3-putt is almost assured, and a 4-putt is not out of the question.

One legendary tale about Bel-Air's 10th hole involves member Howard Hughes and Indian Gus, a club caddy. Hughes made a bet with his longtime playing partner George Von Elm that no one could throw a golf ball over the canyon, some 150 yards wide. "Not true, Howard," Von Elm replied.

"Betcha five hundred dollars it can't be done," Hughes replied. A few minutes later Von Elm came out of the caddyshack with Indian Gus. Without hesitating, Indian Gus pulled a golf ball out of his pocket and heaved it to the distant 10th fairway. Hughes blanched a bit and paid his debt. The next day, still miffed by Indian Gus' achievement, Hughes wanted to bet again. Von Elm obliged. He found Indian Gus again and he hurled a ball over what some called canyon de diablo. Hughes laughed, paid off the devil and gave up the bet. Others who have tried this same feat still sport sore arms for their efforts.

The 14th hole is a 577-yard par 5 with a narrow driving lane, a fat middle section and telescoping approach for the third shot. Only the strongest of players have tried to hit the green in two shots. Tiger Woods once succeeded in getting "green-high" in two swings. He did it with a 3-iron. But the only known 1-putt eagles have come from professional touring golfers Duffy Waldorf (who played at Bel-Air while on the UCLA golf team) and Ray Floyd, and former football player and celebrity golf pro Dick Anderson.

The "Hitchcock Hole" is the name given to the 15th hole because the great film director Alfred Hitchcock lived in the low-slung ranch house off the side of this 448-yard dog-leg right. Over the years, thousands of golfers have launched drives towards "Hitch's" rooftop, causing more than a few broken windows. The

rotund director always sent the repair bill to the club.

The 17th and 18th holes are strong-finishing par-4 holes. Bobby Jones and Ben Hogan both said that the 17th was the best hole they had ever played.

From a lofty perch above Sunset Boulevard, players tee off the 17th tee toward downtown Los Angeles and the San Gabriel Mountains. The 17th green is hidden behind a stand of trees about 468 yards in the distance. The fairway bends gracefully down and away. If the ball is not faded gradually to the right, a hidden fairway bunker awaits. If a player tempts the natural curve of the hole by trying to fly a ball over the trees on the right, it is often lost forever. The green has strange tilts and dips and gravity-defying rolls that leave more than a few members and their guests grumbling by the time they head to the 18th tee.

The 18th, the second "Swinging Bridge Hole," is the other signature hole. Not long at 384 yards, it's uphill and into a canyon. The green is protected by a bunker fifteen feet

The Swinging Bridge is one of a series of man-made structures that help golfers play Bel-Air Country Club's course. The course also has four tunnels and an elevator that takes players from the 9th and 18th greens up to the clubhouse.

deep. The hole sets up best for the second shot aimed right at the suspension bridge. If, by chance, a player finds his ball at the back of the 18th green and the pin is in the front, there is little chance of getting the ball in the hole in two putts. Like the 10th hole, the 18th green is among the fastest in the city.

In the 1960s, the club brought in modern-day golf-course designers Dick Wilson and Joe Lee to evaluate the course. They expanded the size of the greens and added more bunkers, bringing the total to 86.

In 1974, Robert Trent Jones and his son, Robert Trent Jones, Jr., were asked to give their opinions on the course in preparation for the U.S. Amateur Championship. The tees were lengthened and water was added, most notably on the short par-5 8th hole, where Howard Hughes landed his plane when he was late for that legendary date with Kate Hepburn. Revised per the Joneses' suggestions, the hole is now a much greater risk for both golfers and pilots.

for a backside. Neville pulled a ball out of his pocket and teed up. Using the only club available, a putter, he swatted the ball easily over canyon. Thomas, a 2-handicap golfer himself, did the same. With those two swings, the famous back nine at Bel-Air was born. A small tee area was marked off. It told the clubhouse builders to leave the area next to the foundation clear for the 10th hole's tee box, where it sits today.

To cross the canyon, Thomas commissioned a long suspension bridge, the first of its kind for a golf course, to be built across the expanse. The Swinging Bridge, Bel-Air's now-famous landmark, was built at a cost of eight thousand dollars. The 10th hole, a 210-yard par 3, has become Bel-Air's signature hole.

The course opened for play to members in 1926. The 1st hole was a short par 3. Magically, the inaugural shot went into the cup — a hole-in-one with the first swing, a feat unlikely to be repeated. Today this same hole remains as the 5th.

The original clubhouse was a small starters' hut adjacent to the first tee. It was temporary. The lavish Spanish-style clubhouse was still in the design stage, to be built according to Bell's master plan with locally quarried stones and a rooftop reminiscent of villas in Florence. The new hundred fifty thousand dollar clubhouse was completed atop the hill, seven hundred feet above sea

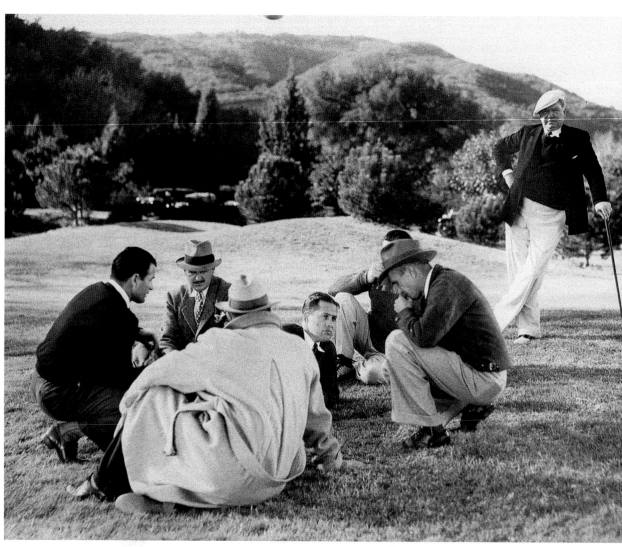

Professional golfer Bobby Jones, reclining, director George Marshall,right, and W.C. Fields contemplate the next shot for Hip Action, *another episode in the instructional golf film shorts Jones and Marshall made for Warner Brothers in the early 1930s.*

level, and overlooked the growing campus structures of UCLA. On the horizon was the Pacific Ocean. On a clear day, Catalina Island was easily visible to the southwest; to the east were the peaks of the San Bernardino Mountains near Palm Springs, more than a hundred miles away.

Thomas developed an innovative access route to get from the golf course to the new clubhouse. He excavated a long underground tunnel from the 9th green, through a hill to a spot just below the clubhouse. He then sunk an elevator shaft down to meet the tunnel. This was a first, as far as anyone knew: an elevator ride from the 9th green into the heart of a clubhouse and bar. Just outside the Men's Bar was the 10th hole over the canyon.

A few years later, Thomas extended the tunnel to reach to the 18th green. The single tunnel ran nearly seven hundred fifty feet in length. It was the beginning of something unique in golf: a course connected by a series of tunnels (four in total) and a hundred-fifty-yard-long suspension bridge. No such construction ideas had been considered in the game prior to Bel-Air.

During Prohibition, many restaurants, speakeasies and clubs violated the law and served liquor to their patrons. The Christian-minded, law-abiding Alphonzo Bell was intolerant of such behavior at his establishment and enforced the law of sobriety. It cost the club dearly in 1927. According to one version of the story, a Bel-Air member organized a golf tournament and banquet at the club. When the club secretary noticed liquor being served, Bell was notified at home. Outraged by the violation, Bell told the member to stop serving the illegal contraband immediately or Treasury Department officials would raid the clubhouse. The member obliged, but the following day he and forty-four others resigned. The club's membership dropped to a perilously low one hundred two. When Prohibition was lifted, Bell caved into pressure from members

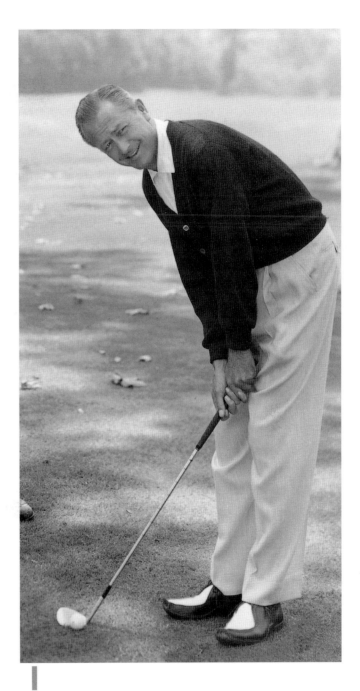

Television's Robert Young from Father Knows Best and Marcus Welby, M.D. *enjoys a practice chip before playing Bel-Air. During summer hiatus, Young was often found on the lush fairways off Bellagio Drive in Bel-Air.*

and agreed to allow liquor to be served on club premises.

As in most of America, the 1930s brought hard times to the elegant environs on the hill. Bell lost a sizable chunk of his fortune and sold off much of his real-estate empire. But about his Bel-Air, he said: "*That* I will always keep."

Although Bel-Air attracted the Hollywood glitterati, Bell felt uncomfortable with Hollywood and its loose morals. His feelings were only confirmed by film comedian Fatty Arbuckle's infamous rape and manslaughter trial, and scared the religious man enough to keep the club's doors closed to "Hollywood types." During this period several famous actors, including Douglas Fairbanks, Gary Cooper, Fred Astaire and Spencer Tracy, were denied membership because of the perceived wicked ways of Hollywood, despite the fact that many of them owned large mansions along Bell's fairways. Finally, in 1932, actor William Powell was accepted, and the doors opened to the industry's best actors and golfers. In celebrities' eyes, membership in West Los Angeles' Bel-Air rivaled the status of belonging to Toluca Lake's Lakeside Golf Club.

The wars in Europe and the Pacific made club life difficult, but on any given day in the 1940s you could walk into Bel-Air's Grill Room and see Hoagy Carmichael or Johnny Mercer tickling the ivories while Bing Crosby crooned. A quick sidestep into the Card Room and there was Hal Roach, the legendary producer of Laurel & Hardy and Our Gang films, dealing another hand of gin rummy. (Roach stopped by Bel-Air almost daily until he died just weeks shy of his hundred-first birthday in 1992.)

During the Golden Era of Hollywood's great studio system, studio vans made daily stops to Bel-Air to retrieve wayward actors ignoring their directors' call times. During the 1940s and 1950s Bing Crosby, Jimmy Stewart, Clark Gable, Gary Cooper, Randolph Scott and Glenn Ford could be found on the course or in the clubhouse hiding from these studio retrievers.

Dick Martin, of Rowan and Martin's Laugh-In, *a longtime Bel-Air member and resident, once had a golf ball fly onto his back porch — a surprise from golf pro Fuzzy Zoeller, who shot it from the 13th tee. Martin called it the first "house in one" ever.*

The Actor's Hole

Bel-Air Country Club has many famous holes, but none is more loved by Hollywood celebrities than "The Actor's Hole," the 13th. It has been aced by more well-known actors than any other in town. Famous players to score a rare hole-in-one there include Clark Gable, Howard Keel, Fred Astaire, Dennis O'Keefe, Ray Bolger, Mike Douglas, Bob Sterling and Lloyd Nolan

The hole is a par 3, running two hundred thirteen yards with out of bounds to the right and a cement creek that catches balls pulled a hair left. The bunker fronting the 13th green is one of the deepest and most sever on the course.

At the 13th tee, Dick Martin (of *Rowan and Martin's Laugh-In* fame) pointed out his home to his playing partner, pro Fuzzy Zoeller. Fuzzy looked up at Martin's porch, which was perched high on the hillside overlooking the canyon about three hundred yards up, and made a proposition.

Fuzzy said: "I'll bet I can land it in your armchair." Fuzzy took a few lazy practice swings and ripped a shot over the 14th fairway, up the side of the canyon and, as predicted, landed his ball precisely on Martin's front porch. Ever since, Martin has called it the first "House In One" ever

Screen legend Clark Gable poses after his hole-in-one at Bel-Air's 13th, known as the "Actor's Hole" for its many celebrity holes-in-one. Initially, Bel-Air's founder Alphonzo Bell shunned the Hollywood crowd, but William Powell and Gable were among the first Hollywood celebrities allowed to join the club.

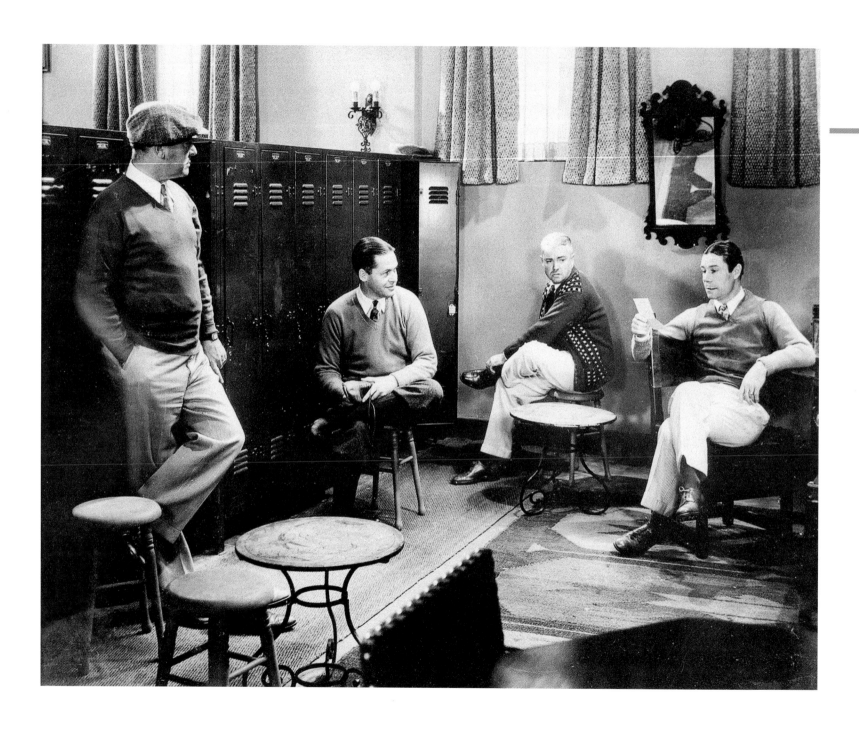

Comedian Joe E. Brown, far right, and legendary golfer Bobby Jones, seated second from left, reflect on a day's golf in George Marshall's famous 1931 series of instructional films. The scene was filmed in Bel-Air's locker room.

In the 1960s, 1970s and 1980s, those greats were replaced by Dean Martin, Bob Newhart, Mike "Mannix" Connors and Dick Martin of *Rowan & Martin's Laugh-In*. Television talk-show hosts Tom Snyder and Mike Douglas and actor James Garner are still regulars on Bel-Air's manicured fairways and in the stone-and-wood-paneled Men's Grill.

Today, the list of Bel-Air luminaries is still impressive. It includes Bob Newhart, James Woods, Richard Crenna, Robert Loggia, George C. Scott, Robert Wagner, Jack Wagner, Joe Pesci, Jack Nicholson, Engelbert Humperdinck, Anne Archer, Chris O'Donnell, Glenn Frey and many studio heads, producers, writers and agents, including Disney's Michael Eisner and one-time super-agent Mike Ovitz.

Newhart was at Bel-Air one morning, playing alone as he customarily does. As he stepped up to the 2nd tee, he noticed two gentlemen in the fairway hitting their second shots. One golfer was slender with a graceful, smooth swing, the other fellow was short and stocky, with a swing that was less than pretty. Newhart hit his drive and approached the two golfers to join them. To his amazement the pair turned out to be ballet legend Mikhail Baryshnikov and character actor Joe Pesci. Newhart says it was of the strangest golf pairings he had ever seen.

Bel-Air's relaxed atmosphere and the camaraderie of its membership have long been part of its allure. Its roster has been neither too saturated with casual Industry types nor too stiff with buttoned-down bankers and lawyers. Bel-Air was, and is today, valued for its balance.

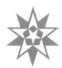

Chapter Seven
Riviera Country Club

In 1927, Frank Garbutt stood on a scar of land called Rustic Canyon, a narrow slot between the Santa Monica Mountains and the Pacific Ocean. It was a wasteland full of sandy *barrancas*, spindly sumac and sycamores, and overrun with coyotes and jackrabbits. Despite its sorry state, Garbutt, head of Los Angeles Athletic Club in downtown Los Angeles, envisioned a new playground for his club members — he would call it the Los Angeles Athletic Club Course at Riviera Country Club.

The land was purchased from none other than Alphonzo Bell, the real-estate magnate who owned much of the land around the Santa Monica Mountains and had founded the Bel-Air Country Club just a few miles east of Garbutt's chosen site on Sunset Boulevard.

Riviera, or "Riv," was to be built on six hundred forty acres in Rustic Canyon. Garbutt dreamed of a European-style sportsmen's retreat, a citadel of western golf. Garbutt referred to his project as "The Pine Valley of the West," in honor of the great New Jersey golf mecca outside Atlantic City. (Pine Valley still ranks as the number-one golf course in the

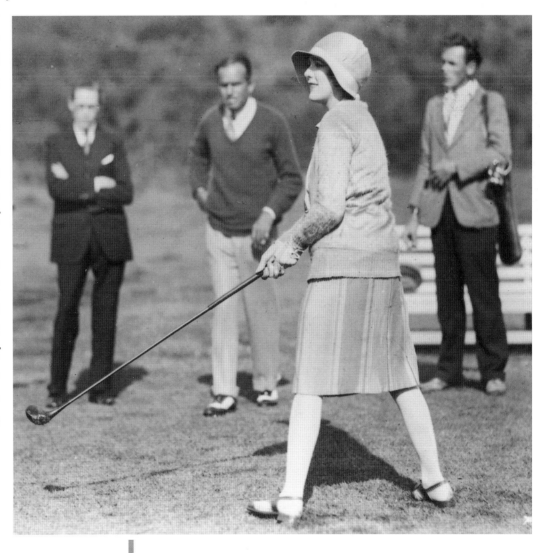

A stylish Mary Pickford watches another well-struck drive on the manicured fairways at Riviera. Husband Douglas Fairbanks, seen in the background, loved to challenge her at "Riv" and donated money to draw the best players to tournaments held at the course.

Situated between the Santa Monica Mountains and the Pacific Ocean in Pacific Palisades, Riviera Country Club is considered by many to be the best golf course in southern California. It was an early playground to some of Hollywood's biggest stars.

Hollywood's Greatest Golf Course

Riviera Country Club has always catered to the serious golfer. The man who did that catering was George Thomas, Jr., designer of some of the West's greatest golf courses. Thomas liked the challenge of Riviera, but Frank Garbutt, the man who hired him, had a blustery manner that annoyed the well-to-do Thomas. Garbutt's demeanor was disgruntling enough for Thomas to turn down the assignment at first. According to Thomas, it was taking him away from growing roses, his other passion.

Finally wooed to accept the challenge, George Thomas blessed Riv with more than its share of his signature holes. One of his key design principles was that "length is secondary to character," as he often said. His philosophy was that the course demanding the greatest number of placements from the tee and the most diversity of shots from both tee and green, is the best course.

Despite this challenge, the 2nd hole at Riviera is a long par 4 and runs a full 463 yards, a little uphill at the green. It's ranked one of the toughest holes on the PGA Tour. The 3rd hole is another par 4 hole, 434 yards long, and was intentionally designed as part of Thomas' opening strategy, to avoid a congestion of players at the beginning of a round.

But the 4th hole is Thomas' true Riviera masterpiece: a long par 3, measuring 240 yards from the back tees. His original plan was to have a grand mound on the right side of the hole, skinned smooth with grass clipped short so that players could make running bank shots into it and have their balls swing left off the mound and roll onto the expansive green. It's a long "bump and run," in golf parlance. Of course, stronger players could fire directly at the flag, but a deep bunker was placed in fron of the green to catch weak shots that came up short.

Ben Hogan lavished praise on the 4th hole, calling it the greatest par 3 in America. The legendary golfer liked the hole so much that he demanded that his golf club company film its TV commercials there. Director George Marshall filmed golf great Bobby Jones there, demonstrating proper technique, for one of his many 1930s instructional golf shorts.

The 6th hole is another Thomas signature, originally designed to play under 150 yards. This par 3 may be Thomas' most enduring gift to the game. Though not long at its final 175 yards, the hole is a classic with its solitary bunker placed in, of all places, the middle of the green. Any golfer who plays Riv waits to arrive at this famous hole. Some call it the "life preserver hole," due to its "hole" in the middle.

A few golf course architects have tried to imitate Riviera's 6th, but few have succeeded. As if in homage to Thomas, golf course architects today know better than to emulate this design.

Riviera's 10th hole, a "driveable" par 4, is another original. Perhaps no single hole, other than the 18th, holds as much drama for both the player and spectator. Certainly, other "driveable" short par 4s existed prior to Thomas' 10th at Riv, but none have held up so well over the years and, in fact, the concept is as popular today among golf course designers as it has ever been.

Golf great Jack Nicklaus calls the 10th "one of the greatest holes in championship golf." At 311 yards, monster hitters of today such as John Daly and Tiger Woods give crowd-pleasing rips with drivers or 3-woods. There's nothing tricked-up about the hole. No water or out-of-bounds exist. It's the gamble of "going for it," or not, that gives the hole its signature. Of course, there isn't much of a percentage in going for it. The narrow green is

Legendary golf course architects Billy Bell, left, George Thomas, Jr., center, and Dr. Alister MacKenzie during the construction of Riviera Country Club. Thomas created several signature holes there, including the famous 6th "life preserver" hole, with a sand bunker in the center of a round green.

well protected by a slender bunker and the green tilts away from players.

Again, Thomas developed a new par-3 concept at the 16th hole. He designed, with three different sets of tee areas, a winter tee, summer tee and a spring/fall tee box. Each played away from the sun of the season. Not a long par 3 when first designed at 110 yards (winter and summer) and 130 for "regular" tees, the 16th still proves to be a challenge due to the tiny, "island" green virtually surrounded by bunkers. The hole is now 165 yards, but the island concept is still intact.

Nicklaus names Riviera's 18th on his list of greatest holes in golf, too. If there can be only one signature hole at Riviera, it's the 18th. It is longer than it reads on the scorecard at 454 yards. It is a par 4 with an "invisible" fairway that slides uphill and around a bank of eucalyptus trees on the player's right side. The fairway is hidden from view on the tee. On the left, a steeply banked hillside seems friendly enough to hit into, but the grass is thick and spongy and filled with nothing but impossible sidehill-downhill lies. If a player is lucky enough to hit a dead-solid perfect drive, with a nice fade to the right about 250 yards, then stage one is accomplished. The next stage is executing the long second shot, about 190 yards into a green set against a the natural amphitheater, on top of which stands the grand clubhouse.

The 18th at Riviera has more memories in it than any other hole in the West. It defines Riv.

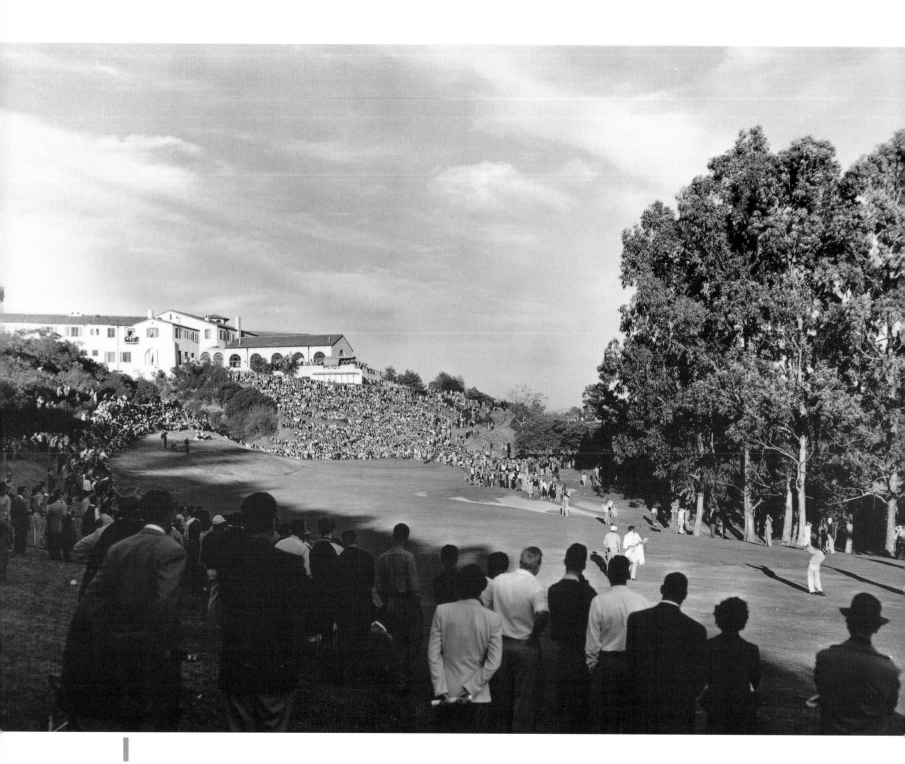

Riviera's famous clubhouse serves as a dramatic backdrop for Sam Snead, far right, hitting into the 18th green during the 1950 Los Angeles Open.

United States.) He also wanted to evoke an old-world charm at his new creation, something, he told friends, you could not get in New Jersey. Unlike Pine Valley, Riviera was to include polo grounds, an Olympic-caliber equestrian center, an archery range and two championship golf courses. In the end, only one course was built and it was designed by George Thomas, Jr., the well-known Philadelphian yachtsman, expert rose grower and renowned golf course designer.

By 1927, Thomas had designed some of the West's greatest golf courses — and all at no fee. His finest design work was spread along the sparsely developed stretch of land along Sunset Boulevard from Beverly Hills to Bel-Air, and included Los Angeles Country Club's North Course and the tight, canyon-hugging Bel-Air Country Club course. Thomas brought along his master golf-course builder, Billy Bell, as his right hand for Riviera.

In the mid-1920s, the average cost of building a golf course was seventy thousand dollars — the tab for Riviera's first 18-hole course came in at two hundred fifty thousand dollars, without the clubhouse — a staggering sum. But the city's golf enthusiasts were thrilled with the final results: a challenging course for the poor-playing "dub" as well as the best professionals in the world.

It took another three years and four hundred fifty thousand dollars to complete the forty-six thousand-square-foot Mediterranean clubhouse. With its thirty-six guest rooms, grand Italian marble entrance halls, elaborate furnishings and crystal chandeliers, it easily earned its nickname "The Grand Hotel of Golf." Today, Riviera still serves as a hotel, though few think of making reservations there when visiting Los Angeles.

From its beginning, Riviera became a gathering place for people who enjoyed the sporting life, particularly those who were serious about their golf. Membership fees ranged between eight hundred dollars and a thousand dollars when the club first opened. The sums were unaffordable for ordinary folk, but for people like Hollywood's most famous couple, Douglas Fairbanks

and Mary Pickford, it was pin money, and they, in particular, wanted the club to succeed.

The Fairbanks/Pickford membership brought along friends such as Sam Goldwyn, Lakeside members Johnny Weissmuller, Basil Rathbone, Adolphe Menjou, and Harold Lloyd, who had his own nine-hole course (designed by Augusta National architect Dr. Alister MacKenzie) in his Beverly Hills backyard. They were joined by legendary drinker and Lakeside golfer, W.C. Fields and Keystone Cops producer Mack Sennett.

But it was Fairbanks and Pickford who were determined from the start to bring the highest level of professional golf to the new Riviera layout. In 1927, the Los Angeles Open was at El Caballero Country Club, located directly over the Santa Monica Mountains near Encino, in and around the old orange groves of the San Fernando Valley. As a way of luring pros down to Riviera, Fairbanks offered any pro shooting a 1-under score of 70 a crisp new hundred-dollar bill. He'd give two of them to anyone shooting 69, three for 68 and four for a 4-under score of 67. It was inconceivable that anyone would score lower. And no one did, at least not in that first year.

In 1929, Riviera found its place on the international golfing map when it hosted the Los Angeles Open, the richest golf tournament in the world, with a purse of ten thousand dollars. To make certain the event happened, Fairbanks kicked in a thousand dollars himself.

Clark Gable split his time between Riviera and Bel-Air when he wasn't tending to his horses at his English Tudor estate in Encino. Although Humphrey Bogart was a regular player at Lakeside Golf Club, he was often seen watching tournaments at Riviera. He was always at his regular spot under a tree on the 12th hole. True to his *Casablanca* style, he wore his signature fedora and trench coat and had a thermos filled with cocktails at his side.

Women members at Riv included Anne Blythe, Olivia de

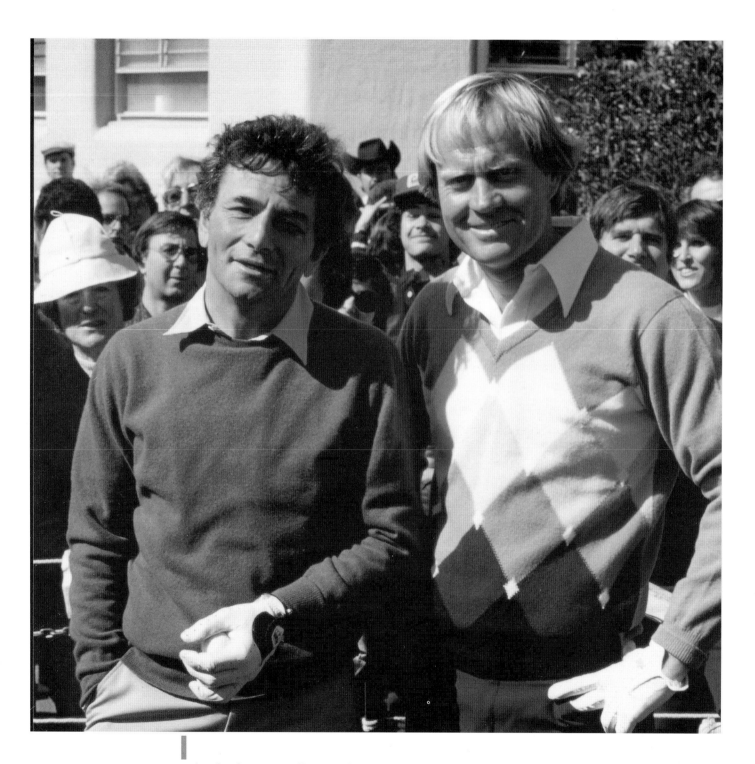

TV's Columbo *Peter Falk gets a chance to play with one of golf's greatest players, Jack Nicklaus, during the Los Angeles Open's pro-am held at Riviera.*

Havilland and Rita Hayworth. Greta Garbo was seen walking the course from her home overlooking the 13th hole, on the same Santa Monica ridge where many stars have homes today.

It was only a matter of time before the movie cameras started rolling at this exclusive club. One of the earliest instructional golf films, *How I Play Golf*, was partially filmed at Riviera, Lakeside and Bel-Air, with world-famous Grand Slam winner Bobby Jones.

But the biggest story at Riv was Ben Hogan. Hogan's tale was filled with all the elements of a good movie: drama, suffering and victory. Riviera became known as "Hogan's Alley" in the 1940s and 1950s, a tribute to his three wins in a row on the course. Over the decades, Hogan's Alley has become home to the annual Los Angeles Open, the U.S. Open, host to the PGA Championship and the U.S. Senior Open.

Hogan's life story is told in the film *Follow the Sun*, one of the few serious films made using golf as a backdrop. Filmed at Riviera just ten months after Hogan's car crash, the movie starred Glenn Ford and Anne Baxter. Scenes were filmed in and around the clubhouse and on the fairways at the club. In one of the final scenes, filmed on the 18th green, Ford makes a putt to beat out Dr. Gary Middlecoff, who made his film debut playing himself, in a re-creation of events.

Jim Backus, one of Hollywood's better golfers, was a regular "Divot Digger" at Riv. He appeared with Spencer Tracy and Katharine Hepburn made their Riviera film debut in the classic movie *Pat and Mike*, the 1952 love story of a scheming sports promoter and his athletic girlfriend. Babe Didrickson was on hand to add authenticity to the movie and to consult on swing technique and golf language.

Riviera's clubhouse was also used for its authentic Mediterranean décor, in the Spanish Civil War movie *Blockade* (1938), with Henry Fonda and Leo Carrillo. The course's rolling green fairways substituted for the English countryside in *Forever Amber* (1947). On a lighter note, in Martin and Lewis' *The Caddy*, a major portion of the outdoor scenes were shot on the 17th fairway.

In the late 1980s, the club's owners, the Hathaway family, who also owned the Los Angeles Athletic Club, sold Riviera for one hundred million million dollars to Japanese investors. Today, the principal owner and manager of Riviera Country Club is the millionaire golfer Noboru Watanabe.

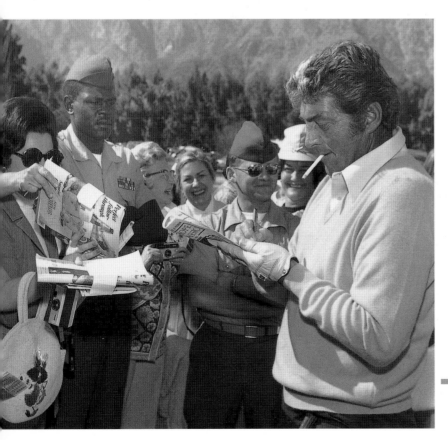

Dean Martin signs autographs for fans during a celebrity pro-am event. Martin played golf daily at Riviera and often went straight from the course to the NBC studios to tape his popular television hit, The Dean Martin Show. *Martin's association with golf was so popular he had his own brand of golf balls called "Dino's."*

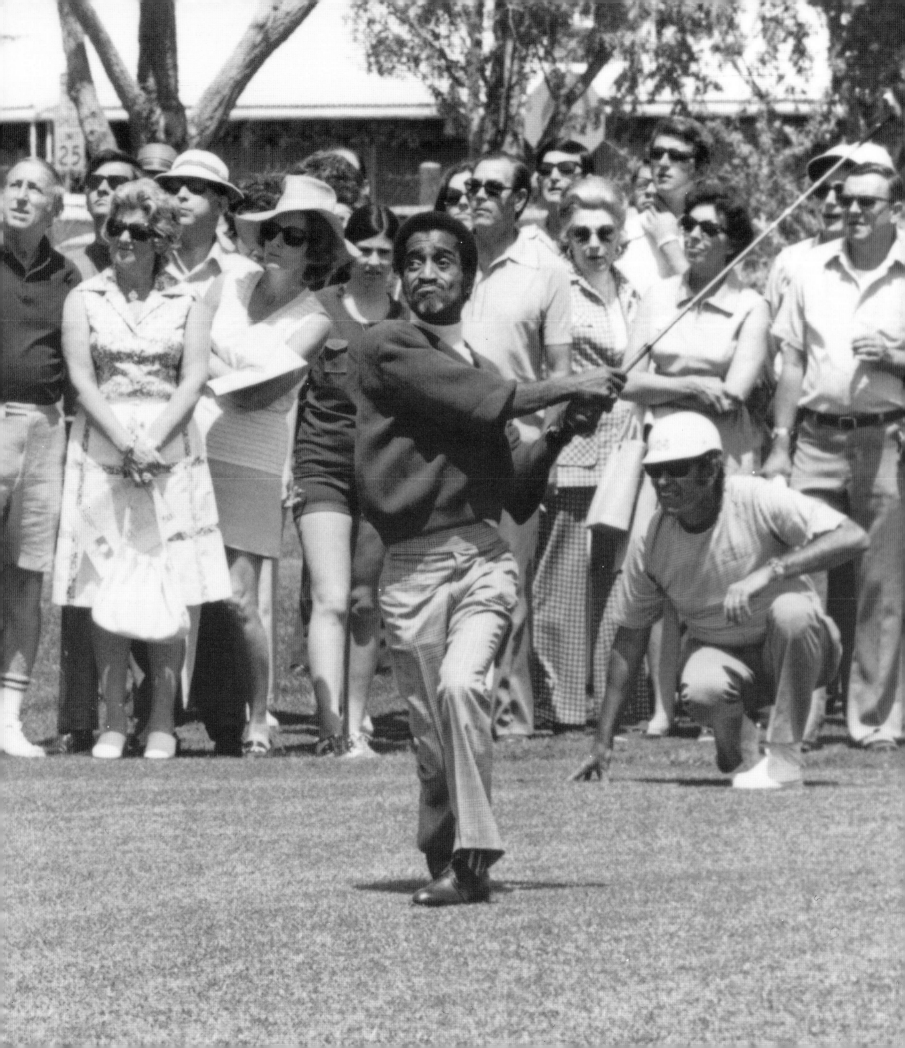

Chapter Eight
Other Renowned Courses

The major golf clubs that were, and still are, the playgrounds of Hollywood's elite crowd have not been the only places to grace the city with their relief of green. Some smaller county clubs are still the favorites of celebrities. And there are many worthy courses that have been plowed under by developers, or were better known for food and atmosphere than for their golf.

One of the Hollywood's most memorable golf clubs destroyed by real-estate development was the old California Country Club, once known as Rolling Hills Country Club. The club's board of directors included Fred MacMurray, super-agent Bo C. Roos, Johnny Weissmuller, John Wayne and Red Skelton. The club opened in 1917, making it one of the city's earliest golf clubs and one of its longest at 6,634 yards. Its staff professional for a time was John "Mysterious" Montague, the trick-shot artist and hustler.

Located on Motor Avenue between MGM and Fox studios, California Country Club was a favorite for celebrity tournaments. For example, the Frank Borzage Motion Picture Tournament brought out Hollywood's A-list, including Bob Hope, Johnny Weissmuller, Clark Gable, Harpo Marx, Dean Martin and Mickey Rooney. California Country Club was eventually sold to make way for the residential neighborhood of Cheviot Hills.

One of the more important early golf grounds in old Hollywood was Rancho Golf Club, known now as Rancho Park. Opened in 1921, Rancho was a semi-private club built by the Ambassador Hotel (ten miles east near Vermont Avenue on Wilshire Boulevard) for use by its guests. It is located across the street from Fox studios.

Sammy Davis, Jr., was a member at Hillcrest Country Club. One morning as he approached the first tee, his playing partners asked him what his handicap was. "My handicap?" Davis replied, "I'm black, I'm a Jew and I have one eye."

The long fairways of Rancho Park Golf Course have been a retreat for many celebrities, including Howard Hughes, Jack Benny, Janet Leigh and Tony Curtis. Actors often played the course while on a break from 20th Century-Fox Studios, far left. The tight layout of Hillcrest Country Club, top, looks as if it is connected to Rancho. The houses of Cheviot Hills, far right, are on the former site of the California Country Club.

It was also home to the some of the city's more notorious hustlers. John Montague picked up games at Rancho, and often played with Howard Hughes or other golf hustlers who blew into Hollywood for action. During the Depression, the federal government took over Rancho for failure to pay back taxes. Many of its regulars, such as Jack Benny, Montague, Hughes and others, moved on to Hillcrest, Bel-Air or Lakeside.

During World War II, Rancho was used as a depot for the U.S. Army. In 1946, the city of Los Angeles acquired the course for two hundred twenty-five thousand dollars. Billy Bell, George Thomas' right hand, and William Johnson redesigned the course to its present 6,500-yard, par-71 layout. The course is challenging enough to handle professional tournaments, including several Los Angeles Opens and PGA Senior Tour Open. The latter tournament has since moved to Wilshire Country Club.

Rancho is known throughout the city as the people's course. Virtually every golfer in Los Angeles has visited Rancho's two-tier driving range. The course's agonizingly slow play is infamous — today a "fast" round takes five hours. Most rounds exceed six hours or longer, often resulting in shouting matches and fisticuffs.

The course still draws its share of celebrities, including Jack Nicholson, James Woods and others who play in the annual Los Angeles Police Department Celebrity Golf Tournament that is held there. Rancho ranks as one of the busiest golf courses in the world with about one hundred thirty thousand rounds of golf played each year. Most private clubs in warm climates average thirty thousand to forty thousand rounds per year. Rancho is so busy and so slow, the joke goes, "In six days, God created the Heavens and Earth. On the seventh day He rested. On the eighth day He played Rancho. Have you heard from Him since?"

Hillcrest Country Club is one of the wealthiest clubs in the city, if for no other reason than it once had several working oil wells on its property. The club was found in the 1921, the story

Actor Fred MacMurray was an early investor and officer of the California Country Club, which was located in what is today Cheviot Hills between Columbia and Fox studios. Like Lakeside, California Country Club was noted for its stellar roster of actors, directors, agents and studio heads.

goes, when two businessmen tried to get into the conservative, restrictive Los Angeles Country Club. Because the men were Jewish, L.A.C.C.'s membership committee suggested they find somewhere else to play.

With no anti-discrimination laws to aid them, the rejected golfers decided to build their own club. They found one hundred ten vacant acres laying south of Pico Boulevard, owned by several investors who were interested in selling. They considered an offer from the two businessmen, and agreed to a purchase price. A year later, the Hillcrest Country Club was built. Its rambling wooden clubhouse was perched on a hilltop near Fox studios and Rancho Golf Club.

Hillcrest was an instant success among the Jewish celebrities in town. It was also a huge financial success since, early on, the members of Hillcrest decided to drill a few test oil wells. In a stroke of poetic irony, they hit oil just about the time that the wells at L.A.C.C. hit dust.

Hillcrest is most famous for its immaculate, modern clubhouse (the original was badly damaged in a fire). The club's dining facilities are better than most four-star hotels. While Lakeside was known for its drinkers, Hillcrest, more than anything else, was known for its food. The club recently renovated its kitchen to standards that can accommodate five thousand guests.

The club is also famous for its roster of actors, comedians and entertainers. Hillcrest opens its doors to all religions and races. One of the first clubs in the country to let blacks become members, Hillcrest admitted Sammy Davis, Jr., and Sidney Poitier. Poitier remains a member today. Sammy's golf swing was a twisted mess, but his love for the game, and the camaraderie of it, pushed him to host his own PGA golf tournament, the Sammy Davis, Jr., Greater Hartford Open. He was not the only Hillcrest member to have a tournament. Dinah Shore was often seen at Hillcrest practicing her game in preparation for her annual Palm Springs event.

From the 1940s through the 1970s, it was not uncommon to see the club's hallways and Men's Card Room filled with the likes of George Jessel, George Burns, Jack Benny, Eddie Cantor, Al Jolson, Kirk Douglas, the Marx Brothers, Danny Thomas and Jack Lemmon. Other big names at Hillcrest have included Frank Sinatra, Tony Martin, Danny Kaye, Debbie Reynolds and Burt Lancaster. These great entertainers often held court at the club's "Roundtable."

There is a price to pay for being a member at Hillcrest. In addition to the expensive entrance fees and monthly dues all clubs require, Hillcrest also demands each prospective member disclose assets and liabilities to make sure he or she can afford membership. Once accepted, members must make substantial donations to charitable organizations. If they do not, they are asked to give up their membership.

Brentwood Country Club also caters to a largely Jewish membership and some refer to it as "Hillcrest West." Brentwood has a roster of great comedians from the 1950s and 1960s, including Jan Murray, Buddy Hackett and Jerry Lewis.

The wide-bodied Hackett was by far the club's best celebrity golfer, often shooting in the high 70s. One reason the club did not have a plethora of celebrity members was because it forbids members from joining other clubs in the city. Few members at other well-established clubs forego those memberships for Brentwood, despite its ideal location in exclusive Brentwood, near Santa Monica, a residential area for many in the Industry.

The famous Holmby Hills "Armand Hammer Golf Course," a par-3 layout, sits in the heart of some very expensive real estate. Rita Hayworth used the 18-hole course to work on her short game. Today, television mogul Aaron Spelling's fifty thousand-square-foot mansion with its long winding driveway can be seen nearby.

Buddy Hackett, one of many comedians who joined Brentwood Country Club, surprises himself with a nice drive. In 1938, the King of Romania purchased the club as a gift for his mistress.

The Brentwood course was built in 1925 and Billy Bell, George Thomas' protegé, was the course designer. Today, its flat, parallel holes stand in stark contrast to the other courses in town, most of which use canyon and hills to stage their holes.

After opening to the public in 1926, Brentwood fell on hard times during the Depression. In 1938 the course was rescued by, of all people, the King of Romania, who presented the course and clubhouse to his mistress as a gift. The King had grand designs for a golf and polo complex similar to nearby Riviera. He kept it open to the public, but he and his mistress rarely visited the club. World War II altered his plans. In the 1940s, the course and club fell into disrepair. The club's one hundred twenty acres seemed headed for real-estate development. Indeed, in 1946 a group of home builders bought the land from the king and tried to develop it for residential use. The city, however, refused to rezone the property. The builders were stuck. So it remained a golf course. Fortunately.

Brentwood has served as the site of two PGA tournaments: the 1952 Western Open, won by Sam Snead, shooting 6 under par, and the scheduled 1962 PGA Championship, an event that was never played at the course. It is because of the latter that Brentwood has a place in golf history.

At the time, the PGA had a "Caucasian-only" players rule. Simply put, African-American golfers were not welcome to play in any PGA tournament. The policy was adopted largely because country clubs during this time generally refused blacks . . . that is, unless they caddied, shined shoes or were part of the kitchen staff. Due to the PGA rule, California's attorney general halted the event at Brentwood, despite the fact that the club was one of

Boxing champ Joe Louis, left, with golf pro Charlie Sifford, one of the first African-Americans to play on the PGA Tour. Sifford paved the way for future African-American players such as Lee Elder, Calvin Peete and Tiger Woods.

City is a small, easy-going golf haven nestled in the flats of Studio City near the Los Angeles River. In 1957, Art Anderson, close friend to Dean Martin and Arnold Palmer, and a young scratch handicapper himself, purchased the range and par-3 course from Kirkwood. Although the par-3 layout is small, the greens are as fast as any in the city.

In the 1950s, it was not uncommon to see the likes of Bogart, Crosby and Hope in the stalls at Studio City. James Garner played and practiced at Studio City while filming *Maverick* at Warner Brothers and later, *The Rockford Files*. Max Baer, Jr., better known as Jethro Bodine in the hit television series *The Beverly Hillbillies*, holds the record for hitting the most balls in one day at the range: eleven large buckets (approximately twelve hundred balls). Afterwards, Baer could not lift his arms.

the few country clubs in America to have an "open race policy." Brentwood was caught up in the controversy, but the PGA, unmoved by California's threatened legal action, shifted the tournament to Philadelphia. The PGA continued its discriminatory policies, at least for a few more months, then changed them later that year. Soon, African-American golf greats such as Charlie Sifford and Lee Edler made their way into the bright lights of big league professional golf, paving the way for other great black golfers like Calvin Peete, Jim Thorpe, Walter Morgan and Tiger Woods.

There are few places in Los Angeles where regular people can go to watch Hollywood superstars play golf without having to be a member or guest at an exclusive country club. The best place to see stars learning the game, flailing and generally having a good time, is the Studio City Driving Range and Golf Course.

Built in 1953 by actor Joe "Joe Palooka" Kirkwood, Studio

Part III

The Modern Era

Chapter Nine
The Game Today

Jack Nicholson flashes a smile during the Los Angeles Police Department's annual Police Celebrity Charity Golf Tournament at Rancho Park. Nicholson was tournament host in 1994, joining a rarified list that includes Dean Martin, Frank Sinatra, Sammy Davis Jr., Bob Newhart and James Woods.

Photo on page 120: Bill Murray shows off his golf swing during Hard Rock Cafe's Charity Tournament at Sherwood Country Club.

Today, golf is as much a part of the Hollywood scene as it was when Bing Crosby and Bob Hope were tallying their best scores. As in the 1930s era at Lakeside Golf Club, today's clubs are the standard setting for deal making, casting and relationship building among foursomes of agents, actors, directors, producers and industry chiefs. Indeed, some of Hollywood's biggest deals have been made on the fairways, and without a doubt, the best place to star gaze is not on Beverly Hills' tony Rodeo Drive, but on the first tee of the elite golf clubs. Among today's biggest stars hooked on the game are Kevin Costner, Jack Nicholson, Bill Murray, Will Smith, Arnold Schwarzenegger, Sylvester Stallone, Clint Eastwood, Richard Dreyfuss, Joe Pesci, Stephen Baldwin, William Devane, Dennis Hopper and director James Burrows. The list is endless. In Hollywood, a game of golf continues to offer the perfect meeting ground for screen stars and golf greats. Professional players such as Tiger Woods and John Daly are mingling with actors such as Kevin Costner, Nicholson and Murray, and depending on the type of fan you are — sports or movie — it's difficult to determine who is the bigger star.

For golf fans who can't get past the guarded gates of private clubs to scout their idols, the next best destination is Studio City Driving Range in the San Fernando Valley where there's the single greatest concentration of celebrity golfers. The range's practice stalls are filled with a *Who's Who* of Hollywood's brightest stars (Schwarzenegger, Dreyfuss, Nicholson, Smith and Pesci, among

Efrem Zimbalist, Jr., "Wonder Woman" Lynda Carter and Arnold Palmer pose for a photo at the 1973 Bob Hope Desert Classic. Hope continued Maurie Luxford's 1940s tradition of having celebrity "queens" at his golf tournaments.

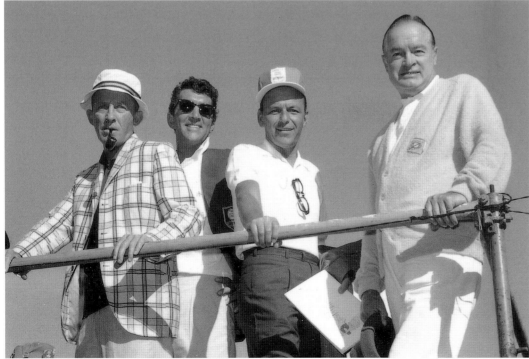

Hollywood golf's "Fab Four" of the Golden Era — Bing Crosby, Dean Martin, Frank Sinatra and Bob Hope — played into the modern era and shared the stage at the Frank Sinatra Tournament in Palm Springs. Even after his buddies passed away, Hope could be found working on his game at Lakeside.

them), because, unlike their silver screen predecessors, few modern stars are particularly proficient at the game. The Hollywood players of two generations ago grew up on golf at plush country clubs, but many well-established celebrities today are playing for the first time. Since they caught the golf bug late, their scores and swings aren't as strong as those of comparable stars of the Golden Era, who were on the course at dawn and played a round or two between scenes.

Ron Del Barrio, the instructor at the Studio City range, says many of his famed clients are determined to do as well on the links as they do on the screen. Sylvester Stallone, for example, is aggressive on the links and has recorded a 74 from the championship tees at Wood Ranch Country Club in the San Fernando Valley. According to Del Barrio, Stallone's greatest barrier to becoming a professional golfer is one of his greatest assets as a superstar: his highly developed physique. Those oversized pectorals and biceps severely limit his ability to swing smoothly,

Del Barrio explains. But with *Rocky*-style determination, Stallone practices as much as anyone in the business, says his coach. He flies Del Barrio in his private jet for intense one-on-one practice sessions near his home in Miami. On movie sets, Stallone often demands a practice net to groove his swing between takes. His devotion to the game even includes dressing for it. Credited with one of the flashiest golf wardrobes among celebrity players, the actor is often spotted in natty Plus-fours and other traditional golf attire more suited to players in St. Andrews, Scotland, than Hollywood or South Beach.

But Stallone doesn't lose his sense of humor while playing, Del Barrio notes. On one occasion in the West Indies with Del Barrio, the hard-swinging Stallone was playing well, but the Caribbean heat made his hands perspire. On one swing, Stallone's club sailed out of his grip and toward a nearby condominium. The club crashed through a second-story window. Quick thinking Stallone grabbed Del Barrio's driver as if nothing had happened. Del

Frank Sinatra, with microphone, introduced a few of his golf buddies, including Danny Thomas, right, and Jill St. John, third from left. A fixture of the modern era, Sinatra's tournaments, like Bing Crosby's, were star-studded events that featured singing, dancing and comedy.

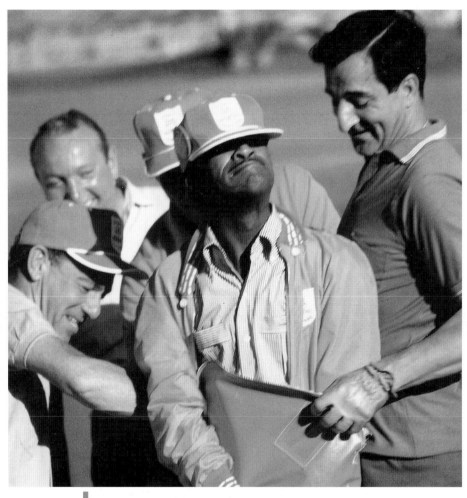

*Danny Thomas, right, and funnyman
Jack Carter, left, stuff Sammy Davis
Jr., into a golf bag to the delight of
tournament spectators.*

Barrio laughingly recalls that without a club in his hand, he appeared to be the culprit. The instructor took the heat from an irate homeowner, and sheepishly recovered Stallone's driver.

Kevin Costner worked intensively with pro Gary McCord on his swing for the role of down-and-out Texas driving range pro Roy McAvoy in the film *Tin Cup*. Costner has quickly grown to love the game and with friends Tiger Woods giving him tips, it probably won't be long before his handicap works its way down to single digits.

Another Del Barrio student, actor Richard Dreyfuss first picked up a club while on vacation in Hawaii and was instantly hooked. Between movies, Dreyfuss can be found at the Studio City Driving Range taking lessons. "I believe I have the makings of a civilized golfer, but I will never be a great golfer," Dreyfuss says. Dreyfuss hosted the Los Angeles Police Department's charity tournament in 1998.

Working with a golf master such as Del Barrio has been a habit in Hollywood since the early days. Latecomers to the game in the 1930s and 1940s were devoted to their teachers. Riviera had its share of star instructors, but Willie Hunter was the most noteworthy. Known as the "Rajah of Riviera," the native Scotsman defeated Bobby Jones in the 1921 U.S. Amateur and that same year won the British Amateur. A master teacher and author, Hunter was the private tutor to Douglas Fairbanks and Mary Pickford, Olivia de Havilland, Charlie Chaplin and many of the club's other "Divot Diggers." About the same time, Bel-Air's resident professional Joe Novak taught Clark Gable, Katharine Hepburn and virtually every celebrity member of the club. In the 1950s, Los Angeles Country Club's pro Mike Dorovic worked on the club's driving range with the likes of Jimmy Stewart, Randolph Scott and Dean Martin.

Today, teachers are swamped. Del Barrio has to squeeze in new clients. Instructor Steve DiMarco, who also caters to actors and industry executives, brings his celebrities to his own back-

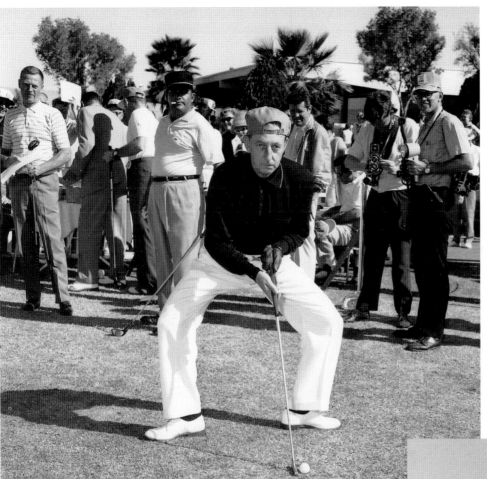

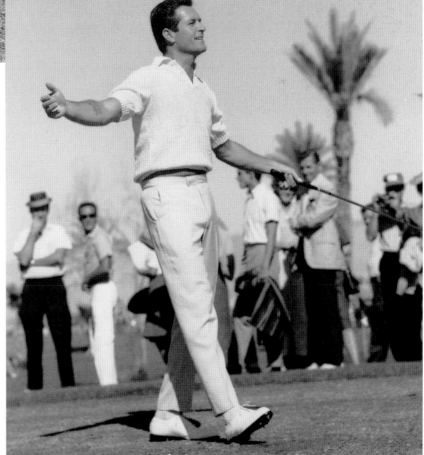

TV's Wyatt Earp *star, Hugh O'Brian, thanks the golf gods as his drive lands on the fairway during play at a charity tournament in the 1960s.*

The Wizard of Oz *Scarecrow Ray Bolger clowns for the crowd. Bolger was an avid golfer and frequently played lightning-fast rounds in the early morning hours at Bel-Air.*

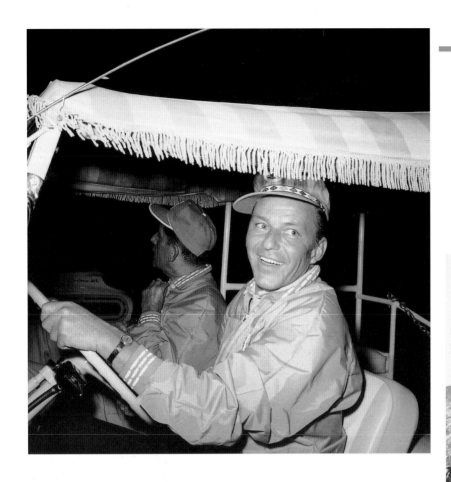

Frank Sinatra makes the rounds in
his signature golf cart at his 1963
Charity Tournament in Palm Springs.

Never regarded as a great golfer, the Chairman of
the Board lived near the Tamarisk Country Club
in Palm Springs and could be seen practicing in
the early evening, after members left and after the
sprinklers were turned on.

yard, where he puts them through drills in a practice area. DiMarco's long list of clients includes producer David Wolper, actors Richard Crenna and Tom Poston, as well as agents and directors. Mike Ovitz, Hollywood's one-time super agent, decided in the early 1990s that he wanted to master the game. Ovitz did not want anyone to see his swing until it was perfected. He worked on it at a private estate in Malibu where a small course was laid out along the ocean. There he practiced in seclusion. At Bel-Air Country Club, he shunned the first tee, and walked down the fairway without taking a shot. He started playing on the second hole, away from the glare of clubhouse spectators.

Throughout history most celebrities have sported what is commonly called a "Hollywood handicap," meaning that the stars (and their publicists) claim they play better than they actually can — sometimes by a wide margin. And today, the Hollywood handicaps are getting lower and lower, the rationale being that registering a low handicap reads well in biographies and in the media. It's also not uncommon to hear ill-informed reporters describe a Hollywood star as a "scratch golfer." Since the early 1920s, there have only been two or three celebrities who would rank as "scratch" or level par golfers. Few Hollywood players have broken 80 in legitimate competitions where par was 72.

Likewise, only an elite group of modern celebrities have been accused of being handicap "sandbaggers," the label for players whose handicaps are higher than their true ability. Television star Jack Wagner (of *Melrose Place* and *General Hospital* fame) and film star Andy Garcia are the only players good enough to get slapped with the "sandbagger" label in recent years. Wagner won several celebrity tournaments with a 4 handicap, when he actually played at par or below. Later, after winning, he simply decided to turn professional. Garcia, a 16 handicapper at Lakeside, was dubbed a sandbagger when he and his pro-partner Paul Stankowski won the AT&T Pebble Beach Pro-Am in 1997. In two days of best-ball golf, Garcia would have scored in the 70s in

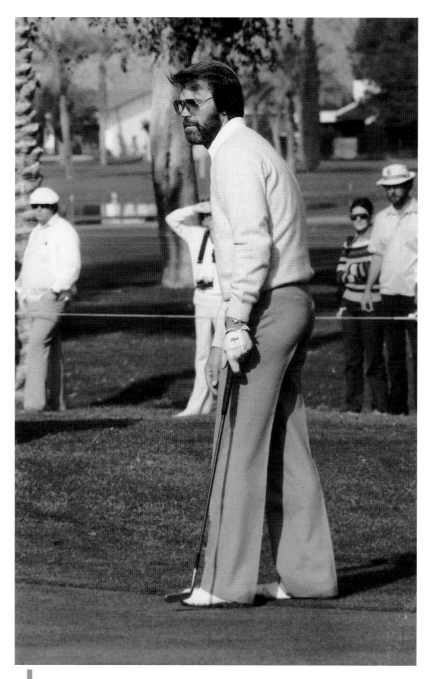

Singer Glen Campbell eyes his putt at the Bob Hope Desert Classic. In the 1970s, Campbell, like a number of celebrities, sponsored a namesake tourney, the Glen Campbell Los Angeles Open at Riviera Country Club.

regular play, according to golf journalists who followed the event.

Wagner, who consistently plays even par golf, or better, is by far the best celebrity player today and could qualify as the best Hollywood player ever. He often wins or finishes high in celebrity tournaments held around the country and one year won over one hundred thousand dollars. In 1990, Wagner won the Pro-Am portion of the AT&T Pebble Beach National Pro-Am tournament as an amateur and played head-to-head with Davis Love III, Paul Azinger and John Cook and other name golf pros. He won his first Celebrity Players Tour event in 1994 in Texas.

Dreaming of professional golf as a career since his first game at age 10, Wagner won numerous local and state titles as a high school student in Missouri, including the Missouri State Amateur Golf Championship. In 1980, he failed to receive a golf scholarship to the University of Arizona, but did get a full scholarship to enter the school's drama program. With that twist of fate, his dual career as golfer and Hollywood star was born.

When playing against long-ball-hitting PGA professionals such as John Daly, Wagner often overwhelms them with his straight drives and deft short game. Former U.S. Open champion and television commentator Ken Venturi says Wagner is among the best putters he has ever seen. Wagner is a member of Bel-Air and has won the club championship several times.

Avid golfer Sean Connery works on his swing as the beloved actress Natalie Wood ducks for cover. At the time, Connery and Wood were working on the film, Meteor.

The Beverly Hillbillies *star Max "Jethro Bodine" Baer, Jr., enjoys a laugh with playing partners Mayfield Marshall, center, and Roger Ward at the Datsun Celebrity Golf Tournament in the 1970s.*

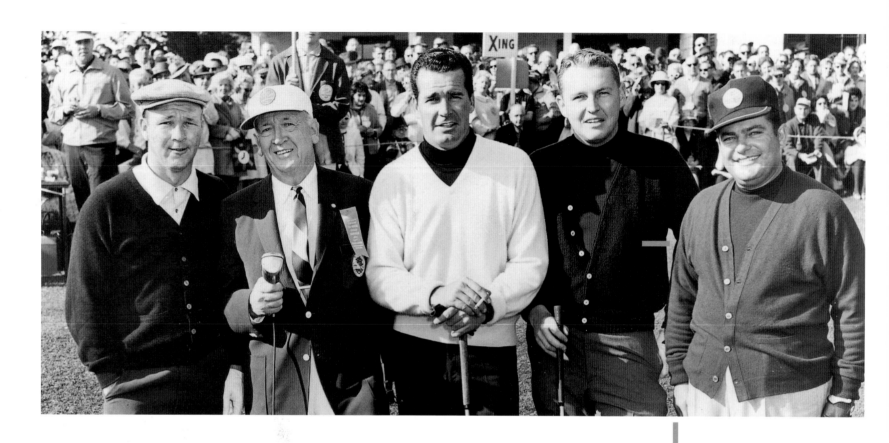

Golf legend Arnold Palmer, left, actor James Garner, center, with Maurie Luxford, second from left, at Crosby's National Pro-Am in Pebble Beach. Palmer's manager Mark McCormick and an unidentified businessman round out the group.

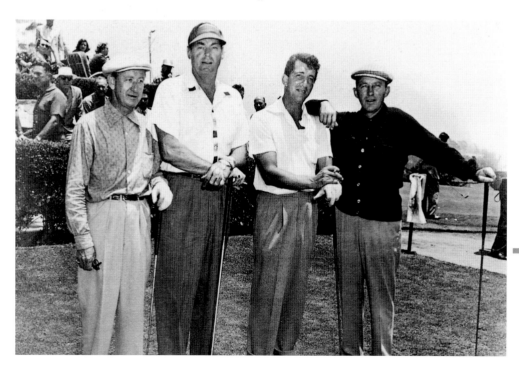

Ross Sparks, left, Johnny Weiss-muller, second from left, Dean Martin and Bing Crosby, far right, get ready at Lakeside's first tee. Today the club is still a golf haven to some of Hollywood's biggest names.

Another solid player — particularly in the 1960s and 1970s — is actor James Garner. Garner has had numerous rounds in the high 60s and low 70s throughout his career. In the 1960s, Garner and western actor, Bob Wilkie competed repeatedly for the top spot in celebrity tournaments. Garner, a one-time legitimate scratch player, slowed down in recent years due to the many injuries sustained from doing his own stunts on his television shows *Maverick* and *The Rockford Files*. Garner's busy movie and television schedule kept him from the practice tee, but he often plays with fellow Bel-Air members Mac Davis, Richard Crenna, Clint Eastwood and Bob Newhart.

Songwriter and entertainer Mac Davis, another longtime Bel-Air and Lakeside member, is an accomplished golfer who came close to winning the Bel-Air club championship in 1990. In the semi-finals, Davis fell victim to smooth-swinging Jack Wagner. Known for breaking into song while he's playing, his 7 handicap fluctuated a bit when he began touring with the stage company of *Will Rogers Follies*. The itinerant life hasn't hampered his game totally, though. His swing remains notable, as does his name, so Davis joined the elite group of rocker Alice Cooper, Motown hit-maker Smokey Robinson and Microsoft billionaire Bill Gates, as celebrity spokesmen for Callaway Golf Club Company's Big Bertha drivers.

Scotland's Sean Connery (a member of St. Andrews, Pine Valley and Bel-Air country clubs) often scores in the 70s and has maintained a handicap near 10 for decades. On two occasions, Connery walked away the winner of the annual St. Andrews Golf Club Silver Jubilee tournament. He also has won several celebrity-pro golf tournaments, including the 1997 Lexus challenge in Palm Springs. Connery says he received more pleasure from winning the 1987 Silver Jubilee than from winning his Oscar for the film *The Untouchables*.

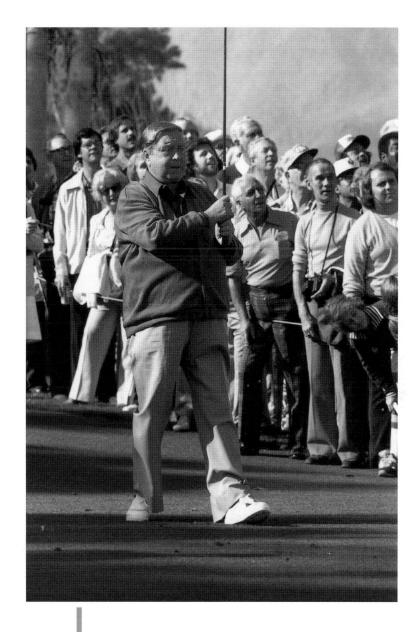

Jackie Gleason watches his drive — and how sweet it was — at the 1980 Bob Hope Desert Classic. Gleason, an avid golfer, moved his variety show from New York to Florida in the 1960s so he could play golf daily. Later, he sponsored his own PGA Tour event.

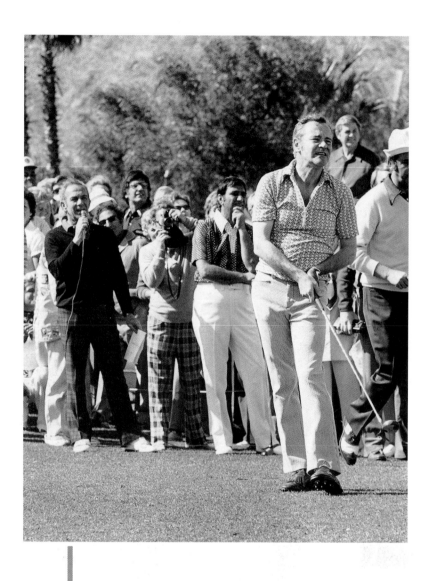

Jack Lemmon tees off at the Bob Hope Desert Classic. Lemmon has been an active participant in celebrity tournaments for more than thirty years. Comedian Jack Carter, left, offers his commentary on Lemmon's swing.

Celebrity tournaments such as the AT&T Pebble Beach National Pro-Am are filled with top box-office draws such as Costner, Nicholson and Andy Garcia. Garcia and his partner Paul Stankowski, who had won in 1997, were again in the lead in 1998 before it was canceled due to heavy rains. The rains were especially disappointing to fans that year, since rumor had it that Bill Murray was planning to play the final round dressed in the camouflage gear he made famous as Carl, the assistant greenskeeper, in the classic golf movie *Caddyshack*.

Clint Eastwood, another regular on the celebrity circuit, sponsors tournaments near his home in Carmel. He carries a 15 handicap and is surprisingly not a big hitter despite his "Dirty Harry" image and height, standing over six-feet three-inches tall. Eastwood is a member at the prestigious Cypress Point Golf Club and Bel-Air. For years, Eastwood has been deeply involved in the charities benefitting from the AT&T Pebble Beach Invitational. He is often paired with professional golfer Ray Floyd. They have made the "cut" to the final day three times, an accomplishment few celebrity golfers have achieved. Eastwood's homage to the game of golf, Tehama Golf Club, will be a links-style course he is building along the scenic California coast near Big Sur, and he has plans for a golf apparel collection under the Tehama label. Eastwood also owns the film rights to the famous golf book, *Golf in the Kingdom*, by Big Sur resident Michael Murphy.

Jack Lemmon, a solid 18 handicapper, has been playing in celebrity tournaments since the early 1950s. A member of Hillcrest Country Club, Lemmon is a passionate competitor, but he admits he is more at ease on the theatrical stage than on the first tee. Despite winning two Oscars, he says his fear mounts just thinking about playing golf in front of huge galleries and television cameras. Lemmon once said he would rather play Hamlet unrehearsed in front of a crowd of theater critics than play golf on television. During one Pebble Beach tournament, Lemmon's first tee shot sliced so badly it bounced through the crowd and into his

hotel room near the fairway.

In golf circles, Lemmon is perhaps best known for his unlucky play in the Pebble Beach tournaments Bing Crosby started. For more than thirty years, Lemmon and his professional partners failed to qualify for the final two days of the event. That ended in 1998, when he and his partner, pro Peter Jacobsen, made the cut. Unfortunately, final rounds were canceled due to rainstorms.

Randy Quaid, a single-digit handicapper at both Bel-Air and New York's legendary Winged Foot Golf Club, is so accomplished on the links that he sported his own swing when he starred in the Dan Jenkins-inspired golf movie, *Dead Solid Perfect*.

Max Baer, Jr. (Jethro on the classic television show *The Beverly Hillbillies*) is a 2-handicapper and one of Hollywood's best long ball hitters. He plays at Westlake Village Country Club in the San Fernando Valley. At the height of his television career in the 1960s Baer played regularly in various celebrity tournaments.

James Woods, who plays to a 19 handicap, tees off weekly at his home club Bel-Air, but his best score to date was 83 on the Hawaiian island of Lanai, where he annually plays in David Wolper's pro-celebrity tournament.

Many young Hollywood celebrities have become serious about their golf games. When not playing on his par-3 course in his backyard or at the exclusive Sherwood Country Club in Thousand Oaks, Will Smith is working on his swing at the Studio City Driving Range with his teacher Ron Del Barrio. One of the best young golfers in Hollywood is Chris O' Donnell, who starred in both *Scent of A Woman* and *Batman and Robin*. O'Donnell plays to an 8 handicap in celebrity tournaments such as the Lexus Challenge and the AT&T Pebble Beach. Also making a name for himself is actor Matthew McConaughey. Though not a member of any club, McConaughey shoots in the 70s and is considered one of the best golfers among new celebrities in Hollywood. Another good golfer without a club is the film and television star George Clooney who scores regularly in the 80s. Though he often plays

Actor Will Smith, center, greets a fan at the Studio City Driving Range while his golf instructor, Ron Del Barrio, right, looks on. Smith is serious about his golf game, installing several par-3 holes in his backyard.

Actor Richard Dreyfuss and golf instructor Ron Del Barrio pose for a picture at the Studio City Driving Range. Dreyfuss took up the game in middle age, but quickly became a passionate player.

"No More Mr. Nice Guy" rocker Alice Cooper awaits his tee time at the Hard Rock Cafe Celebrity Tournament. Cooper plays golf five days a week and is one of several celebrity spokespeople for Callaway Golf Company.

at Sherwood Country Club with cousin Miguel Ferrer, Clooney says he frequently loads his pals into his recreational vehicle and drives to some of the prime resorts in Carmel, Las Vegas or Palm Springs rather than get caught up in the Hollywood country club scene.

New York television talk show hosts Bryant Gumbel, Matt Lauer and Maury Povich qualify as part of the Hollywood team, despite their eastern locale. Gumbel claims to play about a hundred fifty rounds of golf per year, many with *Today* show host Lauer. Povich is one of television's best golfers, having qualified for the 1997 U.S. Senior Amateur. Late-night talk-show host and comedian David Letterman is not in the same class. Letterman mentioned on his show that he played a round of golf once — and shot 150.

So many music stars are regular golfers — Glenn Campbell, Alice Cooper, Amy Grant Eddie Van Halen, Huey Lewis, Kenny Rogers, Glenn Frey of The Eagles and Darius Rucker from Hootie and the Blowfish — that a new breed of tournaments has evolved. The VH-1 Fairway to Heaven and Hard Rock Cafe Charity Tournaments feature singers and musicians from various fields and are aired on the VH1 and MTV music-oriented cable networks, respectively.

After two decades on the links, rocker Alice Cooper admits that he's a golf fanatic, playing almost every day and planning his concert tours so he's near the best courses. When he's at home in Scottsdale, Arizona, Cooper plays with local touring golf professionals, Tom Lehman, Billy Mayfair and Phil Mickelson.

Cooper, like many stars, has used the game as a positive way to escape the pressures of his career. He gave up booze for golf. (His wife said he gave up one bad habit for another.) Likewise, Dennis Hopper credits golf with saving his life. A notorious free spirit in the sixties, Hopper gave up drinking and drugs and put his energies into golf and his acting.

Jack Nicholson's golf swing off the course got him into trouble once. In 1994, he used a 3-iron to bash the front windshield of a car he felt cut him off. The incident, covered extensively in the media, put Nicholson dead center in the golf world. The owner of the car filed a civil lawsuit and Nicholson for a while joked about his "at large" status. The suit was quietly settled.

On the course, Nicholson's scores can range from a reported low 74 to as high as the 90s. Nicholson is known for his liberal interpretation of USGA rules. Nicholson's steady playing partner is fellow actor Joe Pesci, though he is often seen with actor Greg Kinnear and others at any one of the three clubs where he is a member, Bel-Air, Lakeside and Sherwood. In 1998, after he won his Academy Award for Best Actor in *As Good As It Gets*, Nicholson said, "Now I can play golf full time." And he has been trying to be true to his word.

A relative newcomer to the game of golf is the television star Kelsey Grammer. Playing since the early 1990s, Grammer started at a celebrity-studded public course, Malibu Country Club, but joined Sherwood Country Club in 1998. Grammer's approach to golf is the antithesis of the serious player. He never conducts business on the course, or gambles in any way. "Golf is a bucolic endeavor, that allows me to get the rhythm change in life I need," he says. Grammer and the rest of the cast from the television show *Frasier* co-sponsor an annual charity tournament with the U.S. Marine Corps to benefit Toys for Tots. But it's rare that he tees off with other stars in his private hours. Instead, he says he prefers to play quietly with his wife, away from the Hollywood glitz.

Samuel L. Jackson looks at golf in the same way. Jackson is an 18-handicapper who plays at MountainGate Country Club in the hills of West Los Angeles. Jackson has broken 80, but enjoys the game not for the competition, but for its tranquility. Like Grammer, he too started his own charity golf event which benefits Council Partners, an anti-drug coalition.

Despite all the hoopla surrounding Hollywood and its celebrity golfers today, the 1930s through the 1960s produced a much higher caliber of Hollywood golfer than one sees on the links today. In those years, there were numerous talented golfers — those who could regularly shoot in the 70s. Today there are but a few. Perhaps as the young stars, such as McConaughey, O'Donnell, Jackson, and Clooney mature in both their careers and their games, golf will become a greater part of their lives. Many are already devoted to improving their scores. But right now, comparing the modern celebrity golfer to the golfers of the Golden Era, is unfair. Nevertheless, it is certain that in any era the best celebrity golfers have always held their own, both at the tee and under the bright spotlights of Hollywood, drawing crowds wherever they go.

The clown prince of golf, Bill Murray, putts at the Hard Rock Cafe Celebrity Tournament preview held in Los Angeles. Although known for his outlandish attire and antics on the course, Murray is an excellent golfer and loved by fans at many national celebrity tournaments.

Jack Wagner, Hollywood's best celebrity golfer, follows through at the 1997 Celebrity Golf Tour event in Lake Tahoe. Wagner plays most of his golf at Bel-Air Country Club, where he is a club champion. Loose shoelaces are his trademark, helping him not to over-swing.

Hollywood's Greatest Golfers

These two subjective lists rank Hollywood's best golfers from the Golden Era (1920s to 1960s) to the Modern Era. Although it is difficult to compare golfers from these different periods, it is interesting to note which players have been on top of their games and which newcomers will take up the golfing mantle, as Crosby and Hope did seventy years ago, to carry it into the twenty-first century.

The Golden Era — 1920 to 1965

1. Bob Wilkie
(Lakeside Golf Club)
Throughout the 1940s, 1950s, and 1960s, Wilkie won numerous celebrity tournaments. He often shot in the low 70s.

2. Bob Sterling
(Bel-Air Country Club)
A main rival of Wilkie's, Sterling often finished first or second in celebrity tournaments. Former club champion at Bel-Air, Sterling still plays there.

3. Dennis O'Keefe
(Lakeside Golf Club)
O'Keefe, a qualifier for the L.A. Open in the 1940s, frequently placed in the top five in celebrity tournaments.

4. Richard Arlen
(Lakeside Golf Club)
Arlen often shot in the 70s and placed high in numerous celebrity tournaments, usually ahead of Hope and Crosby.

5. Howard Hughes
(Rancho Golf Club, Lakeside Golf Club, Los Angeles Country Club, Wilshire Country Club, Bel-Air Country Club, Riviera Country Club)
Hughes regularly shot in the 70s and was a member of the Lakeside Golf Team.

6. Bing Crosby
(Lakeside Golf Club, Bel-Air Country Club)
Crosby qualified for the L.A. Open in the 1940s. He was also Lakeside Golf Champion four times. Crosby set the standard for golf in Hollywood.

7. Randolph Scott
(Lakeside Golf Club, Bel-Air Country Club, Los Angeles Country Club)
Scott was a fixture on the Hollywood golf scene for many years. He regularly shot in the 70s.

8. Johnny Weissmuller
(California Country Club, Lakeside Golf Club)
Weissmuller finished in the top ten in many celebrity tournaments. A member of the Lakeside Golf Team, he could shoot in the 70s.

9. Bob Hope
(Lakeside Golf Club)
Hope, an excellent putter, at his best was a 4-handicapper. He qualified for the British Amateur Championship.

10. Forrest Tucker
(Lakeside Golf Club)
"Tuck" played in many celebrity tournaments throughout the 1940s, 1950s, and 1960s. He often finished in the top ten and could shoot in the 70s.

Honorable Mentions
Humphrey Bogart rarely played in celebrity tournaments, but was a low handicapper and, much to the surprise of many, was one of the best players among Hollywood's major stars.
Jim "Mr. Magoo" Backus won many celebrity tourneys in the 1950s and 1960s.

Golden Era champion Bob Wilkie celebrates a victory with actress Barbara Eden. Bob Sterling, inset, former club champion at Bel-Air, was his constant rival for the top spot.

The Modern Era — 1965 to the Present

1. Jack Wagner
(Bel-Air Country Club)
Wagner, a scratch golfer and perhaps the best celebrity golfer to play the game in any era, is a multiple-time club champion at Bel-Air and has won professional celebrity events. He often wins against regular PGA tour professionals.

2. James Garner
(Bel-Air Country Club)
In the 1960s and 1970s Garner regularly shot in the 70s. He finished second to Bob Wilkie in several celebrity tournaments. In 1998 he won the Swinging Bridge Tournament at Bel-Air.

3. Sean Connery
(Bel-Air Country Club)
Connery, one of the few celebrity players to be a member of the Royal and Ancient Golf Club of St. Andrews, plays to a single digit handicap.

4. Randy Quaid
(Bel-Air Country Club)
Quaid is one of Hollywood's long hitters and is often a single-digit handicapper. He shoots in the high 70s on a regular basis.

5. Dean Martin
(Riviera Country Club, Bel-Air Country Club)
Martin played more golf than other celebrities of his era. He often shot in the 70s, though low 80s was his usual score. He once shot a 36 on the backside at Riviera.

6. Max Baer, Jr.
(Westlake Village Country Club)
Baer is another big hitter and was also a fixture at celebrity tournaments in the 1960s and 1970s. Today, he still shoots in the 70s and has a 2 handicap.

7. Mac Davis
(Bel-Air Country Club, Lakeside Golf Club, Wilshire Country Club)
Davis scores in the high 70s and low 80s, but below par when he is on his game.

8. David "Joe Isuzu" Leisure
(Lakeside Golf Club)
Leisure frequently practices at the Studio City Driving Range and, under instructor Ron Del Barrio's tutelage, has become a low-handicap golfer.

9. Rick Dees
(Lakeside Golf Club)
The Los Angeles radio personality is a long hitter and uses his distance to shoot rounds in the high 70s and low 80s.

10. Glen Campbell
(Lakeside Country Club)
Campbell has been playing for many years and once sponsored the L.A. Open in the 1970s. He was one of the first modern music superstars to popularize the game.

Honorable Mentions
Chris O'Donnell, Scott Wolf, George Clooney, Bill Murray, Matthew McConaughey.

*Jack Wagner ranks as Hollywood's best celebrity golfer.
James Garner, inset, is a close second.*

Index

ACKNOWLEDGMENTS

In researching and writing *Golf In Hollywood* there were many who offered us invaluable help. We would like to give special thanks to Paddy Calistro of Angel City Press for her steadfast encouragement and guidance throughout this project, as well as Scott McAuley and Jane Centofante for their attention to detail. Thanks, too, to Dello and Associates for the design of this book. In addition we express our gratitude to Stacey Behlmer and the staff of the Margaret Herrick Library at the Academy of Motion Picture Arts and Sciences for her knowledge and generous help. Thanks go also to Marge Dewey and Sondra Sheffer at the Ralph W. Miller Golf Library and Charlene Klink at the Los Angeles Police Department.

Among the many individuals who provided information on the early years of golf in Hollywood, we would like to thank Art Anderson and his Studio City Driving Range; Ted Richards; Carl Hokanson; Jim Mahoney; Bill Maier and Mike Finnell at Lakeside Golf Club; Matthew Allnat at Wilshire Country Club; Geoff Shackelford of the Riviera Country Club; Bill Spector and Matt Levy of Brentwood Country Club; Christie Conti at the Hard Rock Cafe; golf professionals Ron Del Barrio and Steve DiMarco; Charles Hall; Rebecca Woitkoski, golf event coordinator at SMTI in Greenwich, Connecticut; Marshall Thompson of MTA Films; Robin Mesger, Fred Emmert of Air Views; Colin Dangaard and Kelsey Grammer. — R.Z.C. and D.D.P.

PHOTOGRAPHY SOURCES

The authors wish to thank the following people and institutions for making their photography archives available. Every effort has been made to trace the ownership of all copyrighted picture material; in the event of any question arising about the use of any material, the author and publisher will make necessary corrections in future printings. Photos not credited below were loaned by anonymous donors or are part of the authors' private collections.

The Academy of Motion Picture Arts & Sciences Center for Motion Picture Study Margaret Herrick Library: pages 12, 16, 17, 29, 30, 32, 33, 42, 52, 54, 58, 61, 63-65, 105.

Art Anderson and the Studio City Driving Range: page 44.

Celebrity Golf Championship LLC: page 138

Colin Dangaard: pages 131, 135, 136.

Charles Hall: pages 14, 16.

Hard Rock Cafe: pages 120, 136, 139.

Lakeside Golf Club: pages 18, 20, 35, 59, 82, 85, 86, 91, 98, 132.

Los Angeles Police Department-Community Affairs Group, Public Affairs Section: pages 9, 122.

Ralph W. Miller Golf Library: pages 14, 17, 18, 19, 21-28, 30, 31, 34, 36-39, 43, 46, 48, 49, 51, 57, 70, 73, 74, 88, 89, 97, 100, 107, 108, 110-112, 115, 118, 119, 124-130, 132-134.

Wilshire Country Club: pages 66, 77-81.

Marshall Thompson: pages 41, 97.

BIBLIOGRAPHY

Bel-Air Country Club: A Living Legend. Los Angeles: Bel-Air Country Club, 1993.

Blackburn, Norman. *Lakeside Golf Club of Hollywood: 50th Anniversary Book*. Burbank, California: Cal-Ad Company, 1974.

Crosby, Bing, as told to Peter Martin. *Call Me Lucky*. New York: Simon and Schuster, 1953.

Hepburn, Katharine. *Me: Stories of My Life*. New York: Knopf, 1991.

Hill, James. *Rita Hayworth: a Memoir*. New York: Simon and Schuster, 1983.

Hope, Bob. *Bob Hope's Confessions of a Hooker: My Lifelong Love Affair With Golf*. New York: Doubleday, 1985.

McCabe, John. *Babe: The Life of Oliver Hardy*. New York: Carol Publishing Group, 1989.

McHose, John. *The Wilshire Country Club: 1919-1989*. Los Angeles: Wilshire Country Club, 1989.

Shackelford, Geoff. *The Riviera Country Club: A Definitive History*. Los Angeles: Riviera Country Club, 1995.

Windeler, Robert. *Links with the Past: The First 100 Years of the Los Angeles Country Club*. Los Angeles: Los Angeles Country Club, 1997.